# HARROW
## THROUGH TIME
Don Walter

AMBERLEY

This book would never have been possible without the technical assistance of my granddaughter Emily Bahari Modaresi or the decades-long support of the many lovers of Harrow who have made invaluable contributions to my collection of historic local photographs.

*To my incomparable daughters Sarah and Victoria*

First published 2015

Amberley Publishing
The Hill, Stroud, Gloucestershire, GL5 4EP
www.amberley-books.com

Copyright © Don Walter, 2015

The right of Don Walter to be identified as the Author of this work has been asserted in accordance with the Copyrights, Designs and Patents Act 1988.

ISBN  978 1 4456 0608 8 (print)
ISBN  978 1 4456 3742 6 (ebook)

British Library Cataloguing in Publication Data.
A catalogue record for this book is available from the British Library.

Typesetting by Amberley Publishing.
Printed in Great Britain.

# Introduction

As one whose local history books can now be numbered in double figures, it is with some authority that I write – not for the first time – that Harrow is no longer the place it was.

This time around, however, the truly important fact is that the changes are not only bigger and more far-reaching in themselves but they are happening – and seem likely to continue happening – at a far greater speed than ever before.

Certainly the town I first started writing about in the early 1980s – and have known for some eighty-six years – is frequently hard to recognise in the Harrow of 2015.

Happily, there are a few notable exceptions. As many of our pictures reveal Harrow Hill has managed to retain much of its village atmosphere and charm so that someone returning after an absence of even fifty years would immediately feel at home. Much the same is true of parts of Pinner and Stanmore, although having featured in previous editions of the *Through Time* series, they have been excluded from these pages.

In contrast, there can surely be very few Harrow folk who are entirely happy with the development of what we are now encouraged to call Central Harrow or, for that matter, the way in which Wealdstone and, to a lesser extent, old Roxeth (now South Harrow) have suffered a sadly ongoing neglect.

Central Harrow, it must be said, is a relatively new concept. Just a hundred or so years ago, it was the village of Greenhill nestling at the foot of the proper town of Harrow grandly ensconced at the top of Harrow Hill. (This, of course, is why the essentially downhill Harrow Metropolitan Station is still called Harrow on the Hill!)

Throughout the Second World War, and the austerity years that immediately followed, this part of the Borough still had the look and feel of a small market town. Change – when it came in the 1960s with the building of the first high-rise office blocks – was swift and not always well considered. Later, a modern shopping centre (St Ann's) was quickly followed by another (St George's). Welcome in many ways as they were, their look was hardly sympathetic and their sprawl meant the loss of considerable chunks of the 'old Harrow'. Yet, set against some of the town's later acquisitions, they are relatively acceptable.

Of these unwelcome newcomers the most unsuitable must surely be the sequence of gargantuan out-of-scale buildings that have totally ruined the important, once modestly attractive, entrance to the town via the Roxborough Railway Bridge.

College Road has also had its own eyesore for the best part of a decade in the form of a disused Postal Sorting Office. Ultimately we are told it will make way for the latest of a series of promised (threatened?) developments said to cost £9.5 million and to feature at least one residential tower block nineteen storeys high!

To return to the Hill, its position as something of a suburban 'oasis' owes much to the diligence of the amenities group, The Harrow Hill Trust, and to the good stewardship of Harrow School who, in any event, actually own much of the Hill and its famous 'Girdle Of Green'. Even here, however, the recent publication of a comprehensive twenty-year plan for the School and its estates has already provoked some angry comments from residents who feel their beloved setting is about to be rudely disturbed.

Among so many negatives, however, it is cheering to reflect that over a quarter of Harrow is still given over to open space, especially at a time when its population (around 242,400) is the highest ever recorded.

Though barely reflected in a book more concerned with buildings than their occupants, the make-up of this population actually provides us with the biggest local change of all. From a massive local authority document published only last year, we now know that 69 per cent of our fellow citizens come from what are officially described as 'minority ethnic groups'.

Although well beyond the modest scope of this volume, it is to be hoped that one day this new Harrow will be recorded in the depth and detail it deserves. Only in such a way can we all appreciate the fine new buildings in which our newer citizens worship and socialise and, especially important, the often exciting and significant ways in which their presence impacts upon our town ... not merely in shops and restaurants ... but also in cinemas, libraries and schools ... in truth, in just about every important aspect of our everyday Harrow lives.

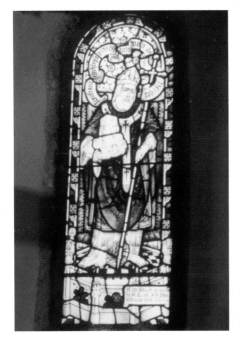

Victorian stained – glass portrait of Archbishop Lanfranc holding a model of St Mary's which he founded in 1087.

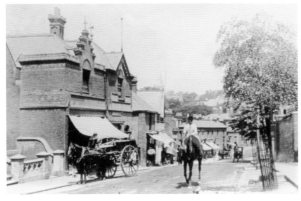

Horses dominate the Hill's High Street traffic *c.* 1860.

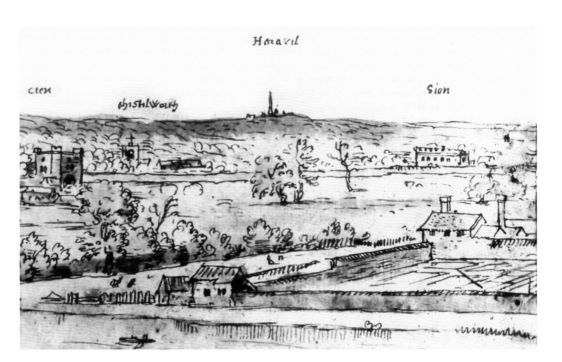

Harrow Hill, *c.* 1554 and 1816

A church and school in some form has now dominated Harrow Hill for centuries, as seen in this greatly enlarged detail from a 1554 drawing commissioned by Phillip II of Spain on his marriage to England's Mary Tudor. Some 250 years later, the print-maker Rudolph Ackermann, working in colour, revisited the self-same scene to record a clearly identifiable St Mary's Church and Harrow School towering above a then largely agricultural landscape.

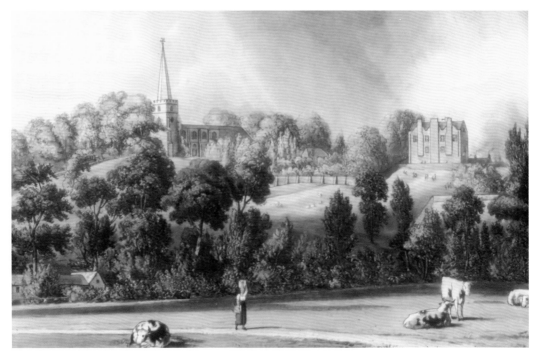

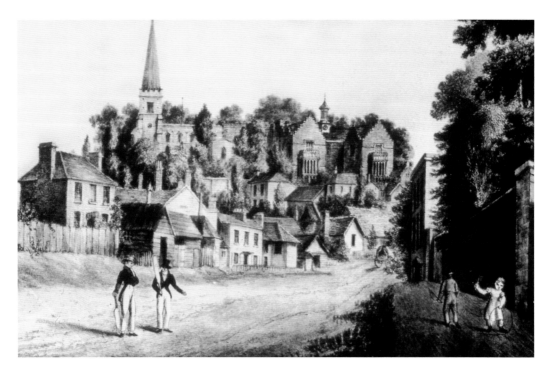

**Harrow Hill Early Nineteenth Century and Late Twentieth Century**
By the 1830s, when Nathaniel Whittock created this charming lithograph, a recognisable High Street of small homes and shops is already taking place in the shadow of church and school. The latter now boasts the imposing double frontage of its 1820 rebuilding. The scene however, is tranquil enough for two young cricketers to pause mid-road without concern for traffic which, since our late twentieth century picture was taken, has seen the Hill become a 20 mph traffic zone.

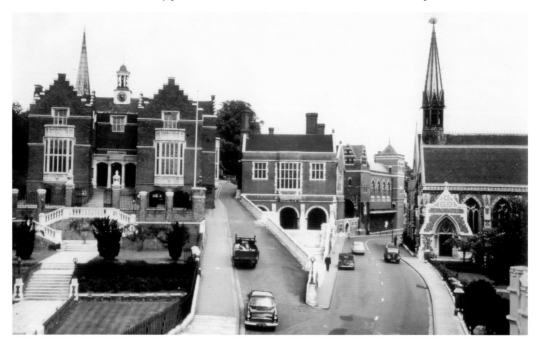

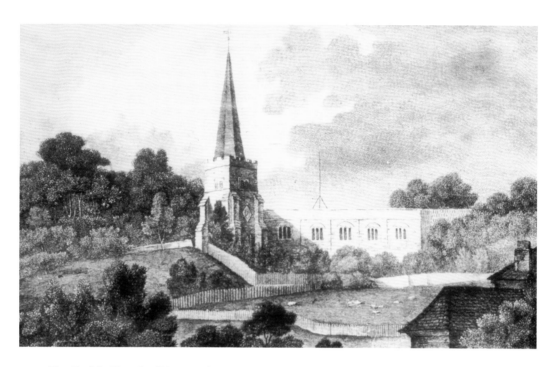

## The Parish Church of St Mary's

Founded by Archbishop Lanfranc in 1087 and consecrated in 1094 by his successor Archbishop (later Saint) Anselm, St Mary's is inevitably something of an architectural patchwork. Although in 1809, when the print above was published, its exterior looked sound enough, some thirty-eight years later Sir Giles Gilbert Scott embarked on a massive restoration programme that gave us today's more Victorian-looking church.

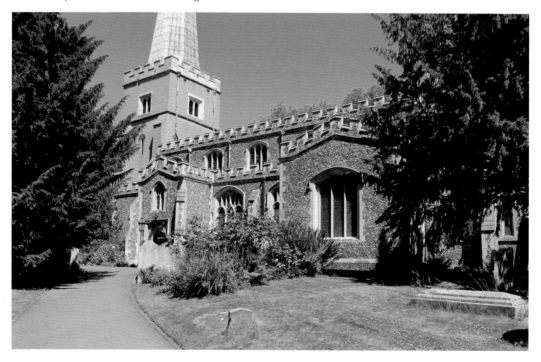

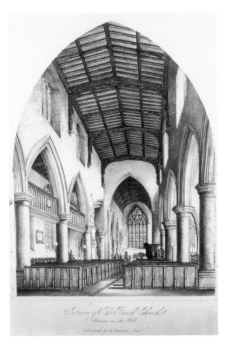
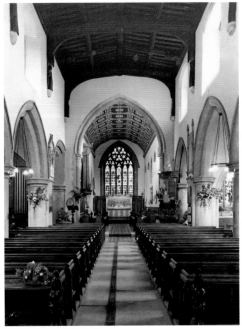

**St Mary's Interior Before and After**

Results of Scott's restoration can be more clearly seen in the church's interior as the before and after pictures (*above*) reveal. Not only did he take down a gallery where Byron, as a Harrow School boy, always sat; he also removed all evidence of the last resting place of Byron's illegitimate daughter Allegra buried there in 1822. Thus, when bones were found beneath the nave late last century, the press – incorrectly – speculated that they were Allegra's. Image below left: courtesy of Jennifer Ransom.

# Do the bones found in St Mary's belong to Lord Byron's Allegra?

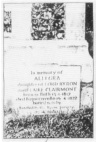
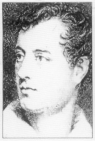
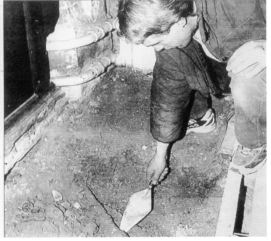

BY EMILY ROGERS

THE human bones found under the floor of a historic church last week could solve a 175-year-old mystery surrounding the last resting place of the remains of the daughter of poet Lord Byron.

The bones were uncovered last Monday by a builder repairing the stone floor in the south aisle of St Mary's Church in Harrow on the Hill. They were later examined by detectives, who concluded they had probably been dislodged from underground tombs nearby.

Local historian Don Walter believes

is that nobody knows the exact whereabouts of Byron's illegitimate daughter," said Mr Walter. "It may be just a wild goose chase, but let's say that there's every possibility that it was a small child's bones, which could point to Allegra.

"If this is the case, the church and the whole country would want to give her a proper burial. It all sounds quite intriguing and the people on the Hill have become equally intrigued."

Allegra, Byron's daughter from a liaison with Claire Clairmont, the step-sister of Frankenstein author Mary Shelley, died of a fever in 1822, at the age of five, after being cared for in a

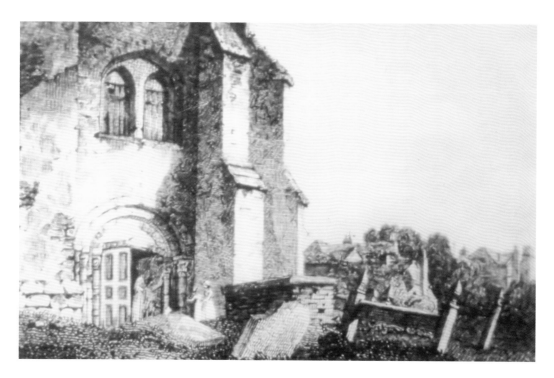

### St Mary's West Door

The addition of St Mary's famous spire in 1440 required the tower and belfry to be strengthened by the vast buttresses seen in the 1810 engraving. With its authentic Norman arch, the tower is the oldest surviving part of the church. Today visitors can also inspect its scarcely less ancient door. This leads into the belfry which at one time housed the first-ever parish fire engine.

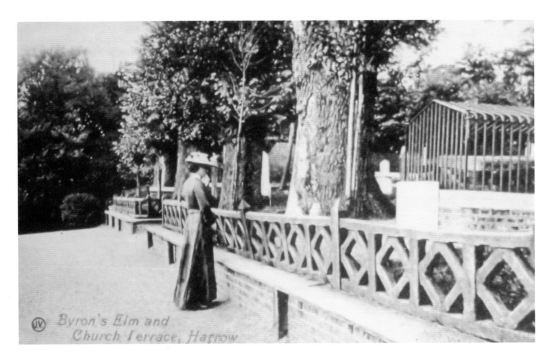

Byron's Elm and
Church Terrace, Harrow

## St Mary's The Peachey Tomb

Visitors to St Mary's viewpoint terrace have long been fascinated by the tomb of one John Peachey which, in Byron's own words, was his 'favourite place' for sitting and writing verses. After the poet's death, so many of his fans chipped away pieces of the tomb as souvenirs that the parish was obliged to cover it with the iron grille seen in our 1910 photograph. It remains to this day although now accompanied by a helpful information plaque.

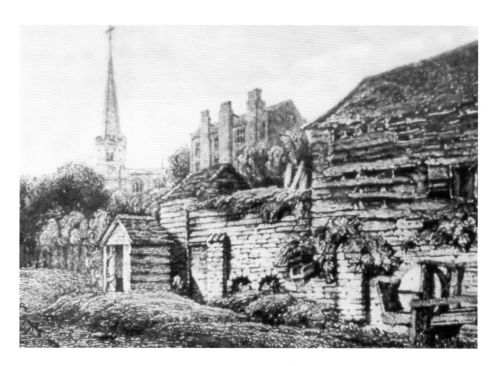

King Charles' Well, Grove Hill

Given the location of this undated print – below St Mary's and the earliest school building – it almost certainly shows the so-called King Charles' Well.

Long since sealed-up, the site is now marked by a plaque claiming that, while fleeing from Cromwell during the English Civil Wars, Charles I chose to stop here to water his horses. Since Harrow was then something of a Cromwellian stronghold, it is highly unlikely the monarch ventured anywhere near the town.

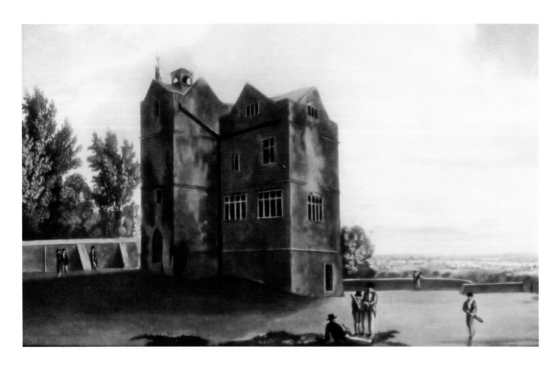

## Old Schools, Harrow Schools

Although Queen Elizabeth I granted yeoman farmer John Lyon a Charter for the foundation of Harrow School in 1572, its first building did not open until 1615 – a fact that gives credence to the much-discussed existence of an earlier school, probably within St Mary's churchyard. The original schoolhouse was virtually doubled in size in 1820 when architect Charles Cockerell added a whole new wing, gracing both wings with enormous oriel windows.

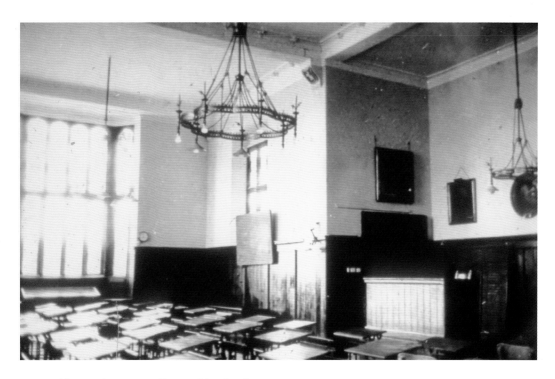

## Old Speech Room Gallery, Old Schools

Although not as famous as the adjoining Fourth Form Room, the Old Speech Room within old Schools has an equally fascinating history. Pictured here at least a century ago, when it also served as a classroom, it was once the scene of all the school's most important orations. Since 1972, however, it has had a new claim to fame as a stunningly designed split-level gallery for the public exhibition of the school's enviable collection of art and other treasures.

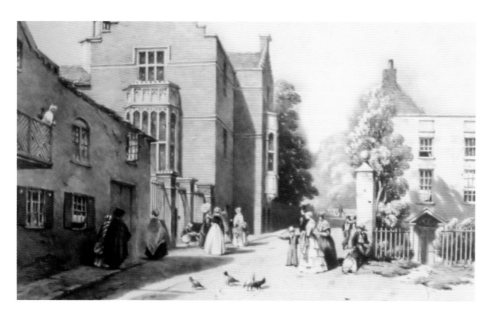

## Church Hill, Early Nineteenth Century

Being the historic road that leads past Harrow School's gates to St Mary's, Church Hill has long received the attention of artists and photographers; among them the school's drawing master Thomas Wood. The semi-rural atmosphere depicted in his 1836 picture (*above*) is even more apparent in the earlier tinted print, showing Church Hill from a different angle. Here the only living creatures are a solitary, well-dressed man – and a foraging pig!

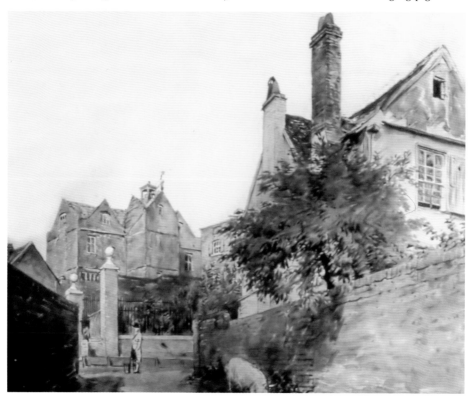

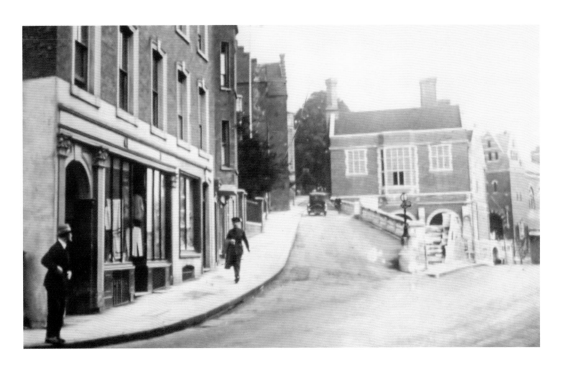

## Church Hill, 1926 and 2015

By 1926 the previously dominant properties – an inn on the left and a Dame's House on the right – had been replaced by a variety of buildings. Of these, the most impressive was the School War Memorial dedicated to the 690 Old Harrovians lost in the First World War. Since then, much that was unsightly has been removed, opening up new vistas and transforming Church Hill into a suitably imposing gateway to both church and school.

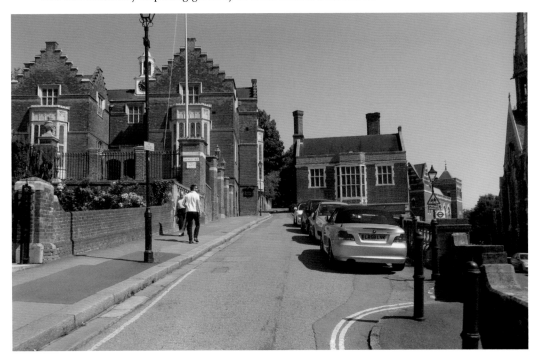

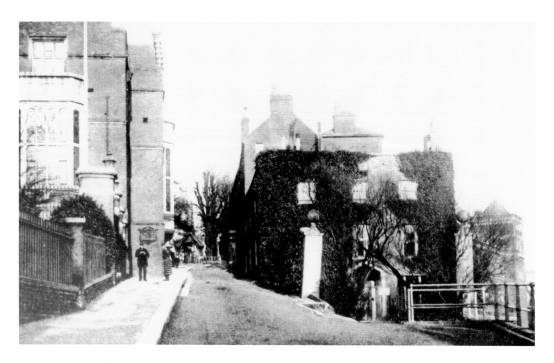

## Dame Armstrong's House, Church Hill

A legacy of an era in which responsible local dames augmented Harrow's staff, Dame Armstrong's House survived into the second decade of the twentieth century when it was among properties cleared for the building of the School War Memorial. In 1999, dozens of pupils found the latter's impressive outside staircase the ideal spot from which to cheer a 'lap of honour' enjoyed by retiring head Nicholas Bomford and his wife.

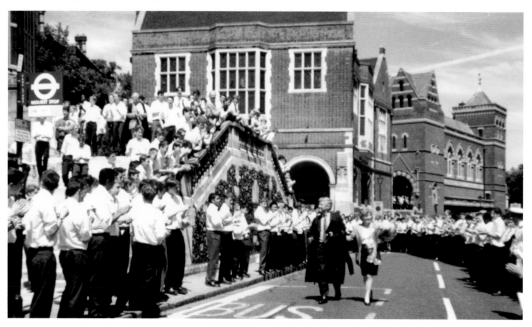

Picture courtesy of Carolyn Leder.

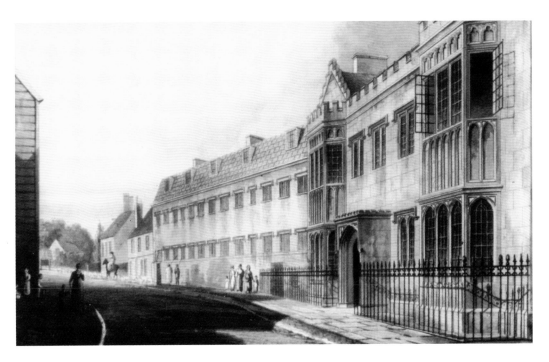

**Fire at the Head Master's, 1838**

By 1816, when Ackerman produced his tinted print, Harrow's Head Masters lived in style in this grand High Street house, sharing it with a number of pupils. Thankfully, all its occupants escaped injury when, in 1838, an early form of central heating caused the so-called Great Fire of Harrow. As depicted in a contemporary lithograph, the blaze was so fierce that, had the wind been stronger, many other parts of the hill-top town would have been similarly gutted.

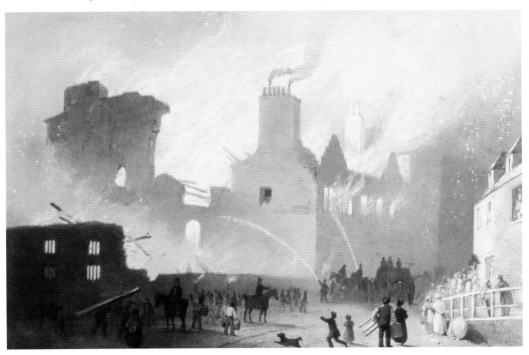

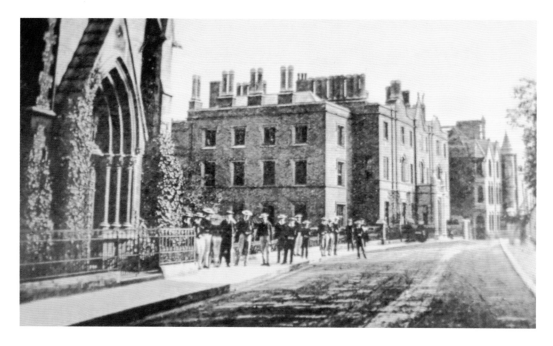

### The Current Head Master's House

Following the fire a new Head Master's House arose, shown above in a street scene taken *c.* 1900. Designed by Decimus Burton, who created The Palm House at Kew, it was home to successive heads until 1982 when a more private residence, Peel House, was built behind the school chapel. The current head master however, has returned to the High Street building whose classic exterior (*below*) has remained much the same over the years.

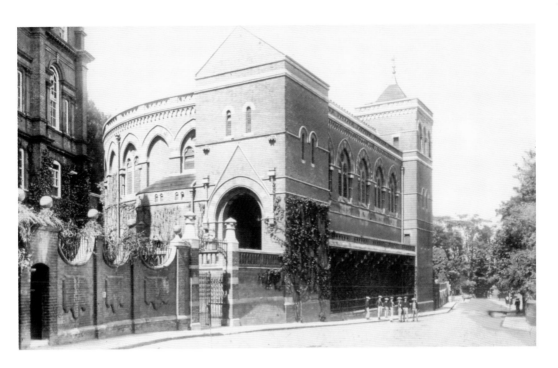

### Harrow School Speech Room

Once the school had outgrown its little speech room, a tercentenary project was launched in 1872 to build this separate assembly hall adjoining the existing Church Hill House. Problems with the sloping site and the controversial designs of William Burges meant that it was not completed until 1877. Even then, it was not universally applauded. The Speech Room we see today' however, has become perhaps the most iconic venue the school possesses.

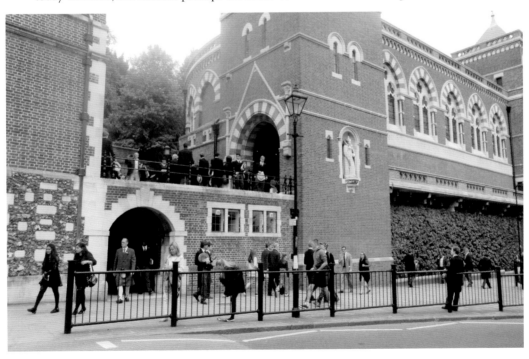

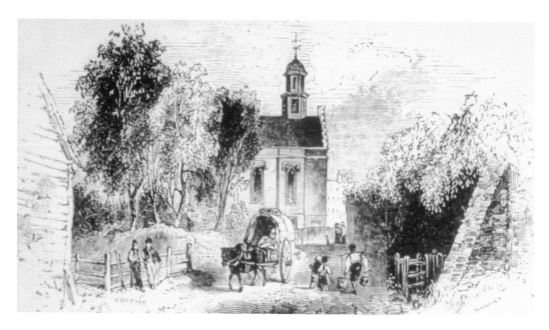

**Harrow School Chapels,** *c.* 1839 and 1855

Amid considerable controversy, 1839 saw Harrow boys moving out of St Mary's (where they had sat uncomfortably in galleries) and into their very own chapel. It was, however, soon out-grown and, in 1855, a grander building arose to designs by George Gilbert Scott. This is substantially the chapel we see today although the spire is a later addition as are the two side entrances apparently designed to stifle 'traffic noise'.

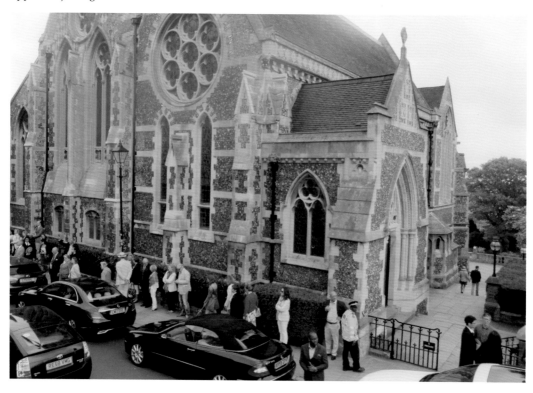

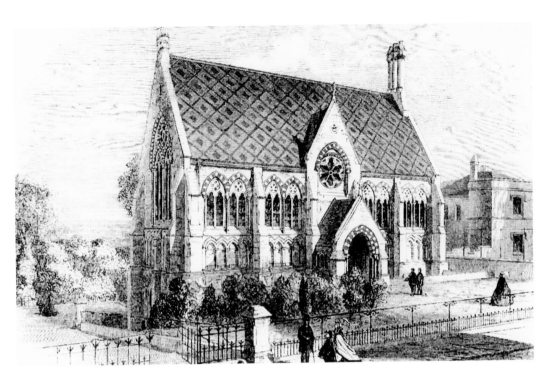

## Vaughan Library, Harrow School

In 1863 the *Illustrated London News* published this drawing of Gilbert Scott's newest creation, a library in memory of Charles Vaughan following his resignation as Head Master some four years earlier. Although neither press nor public then knew that Vaughan had actually been forced to leave because of an indiscretion, it is significant that the library eventually opened without ceremony. Latterly, its interior has been modernised without loss of its Victorian charms.

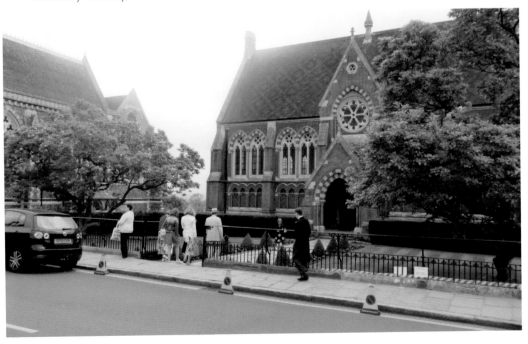

## The Grove, Harrow School

Long before it became a school boarding house, The Grove had important links with the town's history. First, it was almost certainly the site of the ancient Rectory Manor House which once received guests such as Archbishop Thomas Becket. Secondly, a later house on the site was bought by the Harrow-educated dramatist, Richard Brinsley Sheridan, as a home for himself and his singer wife, Elizabeth Linley (*below*).

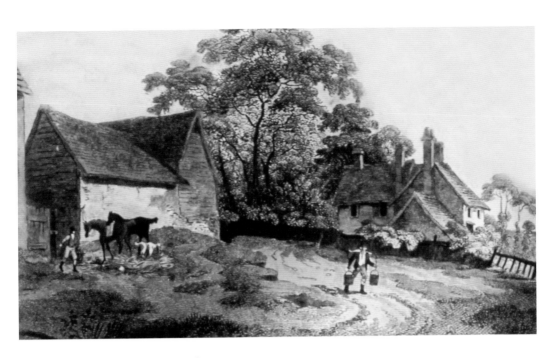

**Sheridan's Stables, 1795 and 2015**

As Sheridan was obliged to divide his time between his Harrow home and London's theatreland, he had need for several horses which he kept in the stables seen in this lively etching inspired by a picture now in the Harrow School collection. When the stables ultimately made way for an additional teaching block, the school kept their memory alive by mounting a simple plaque on the outside wall where it can be readily seen by visitors.

**Garlands, Peterborough Road**

In 1886 Garlands, then a so-called small house belonging to Harrow School, welcomed a young Winston Churchill (shown left on fire escape). He had apparently been a bronchitic child so 'high and healthy Harrow' was chosen for him in preference to damper Thames-side Eton where generations of his family had been educated. Disappointingly, all but the front entrance of Garlands was lost last century when it was transformed into a sprawling Victorian-style apartment block.

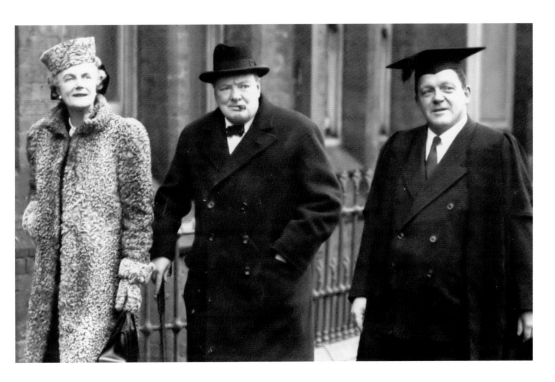

**Churchill Recollections, 1940 and 2015**

Once he was stronger the schoolboy Churchill was transferred to the Head Master's house where he is pictured in 1940 with his wife and the then acting head A. P. Boissier. Given that the war-time premier had previously been somewhat estranged from the school, this was a genuinely momentous visit, one he repeated almost annually to the end of his life. Today, one of the newer teaching blocks is called Churchill Schools in his honour.

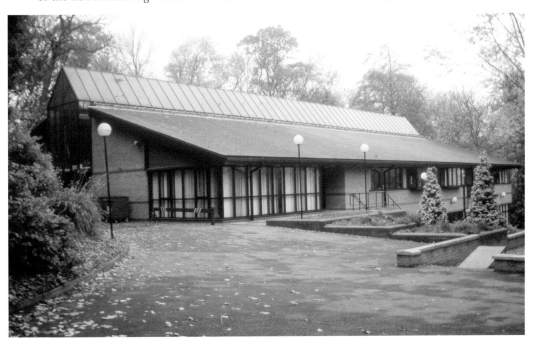

## Church Fields

Late last century, the Yew Walk entry to the beloved open space known as Church Fields became the focus of a serious breakdown in the normally tolerant relationship between town and gown. The cause was the school's decision to site its new Ryan Theatre within yards of the viewpoint depicted in our 1930s photograph. At the breakdown's lowest point, angry protestors even took to the streets, making headlines in the local and national press.

*HO. 9.7.42 p10*

# Theatre project makes mockery of democracy

[ARR]OW School's bursar [sc]olds locals for opposing its [th]eatre-housing estate scheme: "These people have tried [ev]erything to stop the project, [in]cluding a judicial review, [an]d have lost each time" (Ob[se]rver, July 2).

Mr Liddiard should check his [fa]cts. The main opponent of Har[ro]w School's scheme was the Lon[do]n Borough of Harrow, which [al]one asked the High Court to [ov]erturn the Inspector's bizarre [de]cision.

"These people" did not lose [ea]ch time. Were that so, there [wo]uld have been no public in[qu]iry. Harrow Council twice re[su]ndingly rejected the scheme. The school appealed to the De[pa]rtment of the Environment. One [m]an's arbitrary fiat then enabled [th]e school to defy the local com[mu]nity's elected representatives

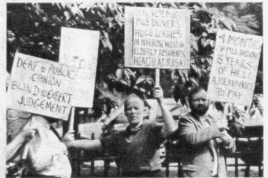

**Protesters outside Harrow School**   Picture: GARETH BEARD

and ignore national outrage.

The bursar appears amnesiac. He claims "opposition every time we put up a building". Nonsense. The school's new sports centre,

the headmaster's house, the central dining complex, the John Lyon theatre went up unopposed by us.

The CDT building too was un-

opposed, save for the suggestion that it be placed where the new theatre is to be – a site then condemned as obtrusive by the same planning office that later approved it for the theatre.

Not Hill residents but Harrow School "try everything" to get their own way.

Villagers intimidated; our MP coerced; and silence on profits from 21 over-sized, mislocated houses.

The bursar is right on just one point. To push through this detestable scheme seems to us an unforgivable, unforgettable mockery of democracy and of conservation. It not only temporarily disrupts the lives of many people, it permanently impairs the quality of life.

**DAVID LOWENTHAL**
**Secretary, Crown Street and**
**West Street Area Residents**
**Association**
**Harrow Hill**

**Church Fields, 2015**
The Ryan Theatre finally got built – as did the small but equally controversial housing estate nearby. Decades later, it can be said that both have settled into the landscape. Even from the Church Fields, the theatre is not the looming monstrosity some predicted. Time and fast growing greenery have also softened aspects of the housing. A clash of styles between the pre-existing cottages and their new neighbours nevertheless remains all too evident.

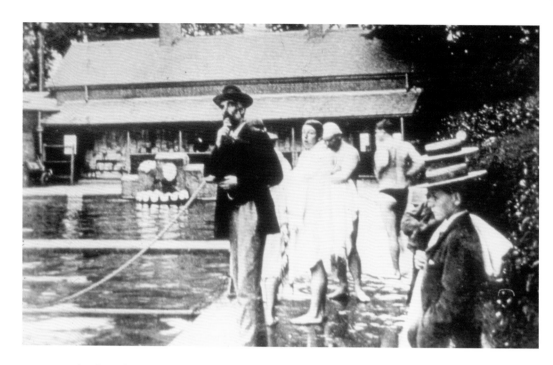

**Harrow School Ducker**

In its so-called Ducker, pictured *c.* 1912, Harrow School had one of Europe's biggest privately owned pools, used not only by pupils but also by fortunate townsfolk. Both groups were saddened when the pool was closed in the mid-1980s following its site's sale to the Swaminaryan Hindu Mission for a temple that never gained planning permission. Subsequently, the School found a new site elsewhere on its estates and built an all-purpose year-round sports complex.

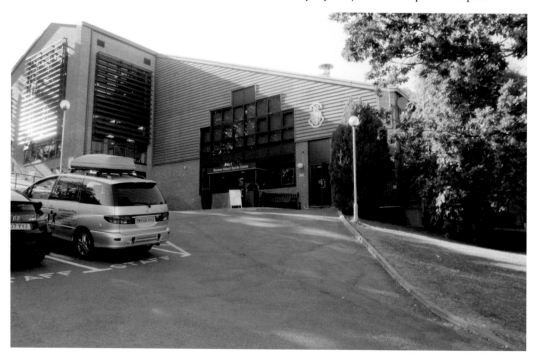

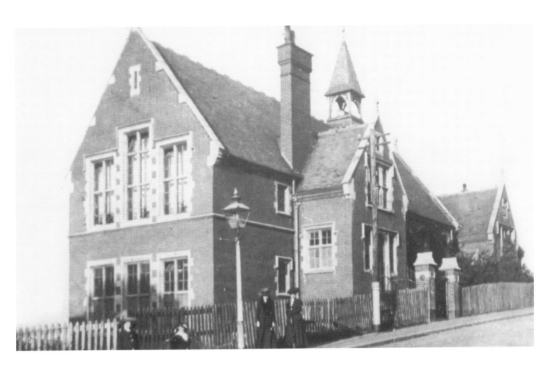

**The John Lyon School, Middle Road**

Once Harrow had become a school more for wealthy 'foreigners' than for local lads, the latter's needs were partly met by the creation of the quaintly named English Form. This was followed in 1872 by the erection of this proper Victorian school-house somewhat patronisingly called The Lower School of John Lyon. With a small but significant name change and ever-growing premises, it is now an important foundation in its own right.

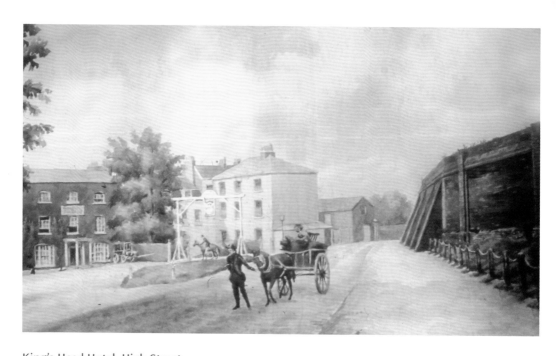

## King's Head Hotel, High Street

Celebrated as the Hill's oldest hostelry, the actual age of the King's Head has long been debated, although for years its façade displayed the date 1535 nevertheless no printed records can be found before 1706. Not in doubt however, is its growth throughout the nineteenth century from the quiet inn of our early colour print (*above*) to a busy coaching station and acknowledged centre of local community life (*shown below*).

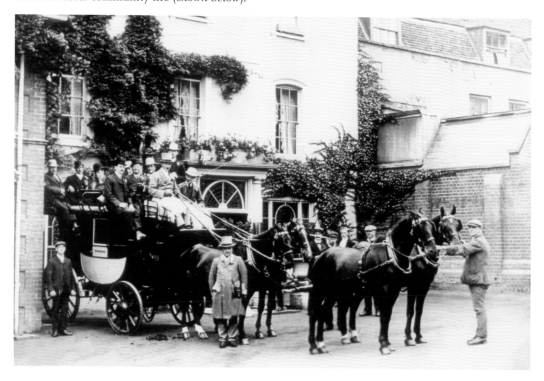

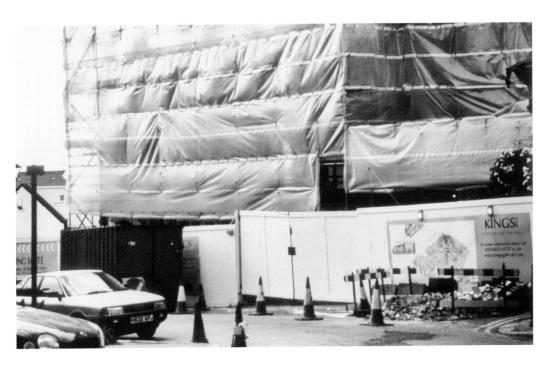

King Henry Mews

Sadly the King's Head failed to survive into the twenty-first century. First, it lost its licence due to poor management. Then, for a period, it became an unlikely refugee hostel. Finally in 2004, it became one vast plastic-wrapped site pending total redevelopment. What finally emerged was better than many anticipated – a beautifully restored façade masking spacious apartments plus a small mews of new properties where once its ballroom had stood

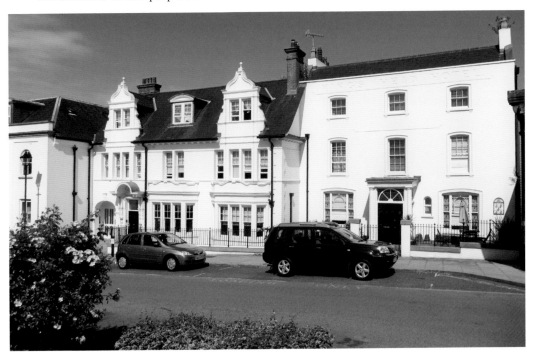

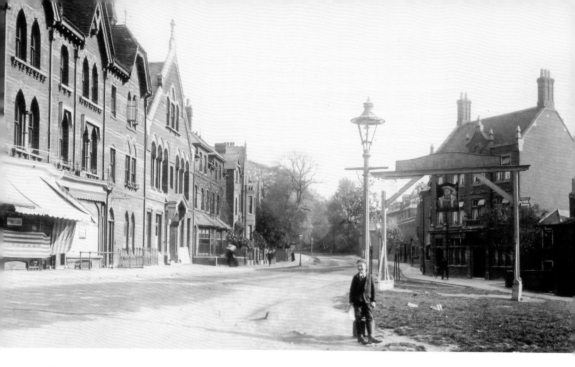

**The King's Head Green**

There could be few better 'snapshots' of the Edwardian Hill than this 1905 view. Though the green itself seems somewhat neglected, the surrounding architecture – only a few decades old – looks suitably imposing. Much of it survives in our present-day picture in which the green now boasts a new oak gantry supporting a Henry VIII portrait and a seat in memory of the author's wife. Both were donated by the Harrow Hill Trust.

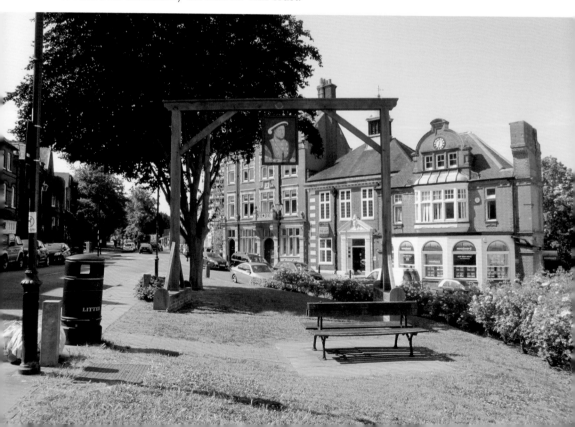

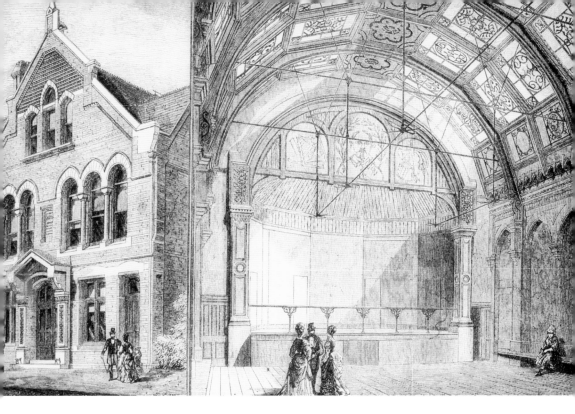

### The Other Side of the Green

Amazingly, this single site has been offering some form of public service for around 130 years. Built as Harrow's Public Hall (whose exterior/interior is shown in our composite engraving) it was later transformed into the Hill's first cinema whose facilities included a free bus service up and down the Hill. Once the Carlton, it was rechristened The Cosy in a patron poll. For some years now, it has been a popular bar/restaurant called Café Café.

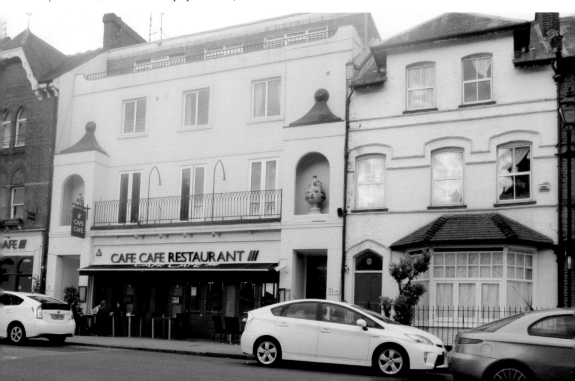

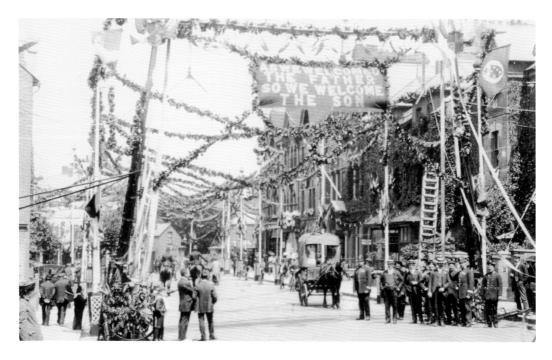

## Celebrations on the Green, 1912 and 2015

Photographs, taken over a century apart, testify to the enduring value of the Green in maintaining the Hill's strong sense of identity. The first, dated 1912, shows Hill Folk preparing a welcome for George V as they had done for his father before him. In the second, people of all ages support the 2015 May Day Celebrations, organised by the Harrow Hill Trust and featuring attractions such as bandsmen, choristers and Morris Dancers.

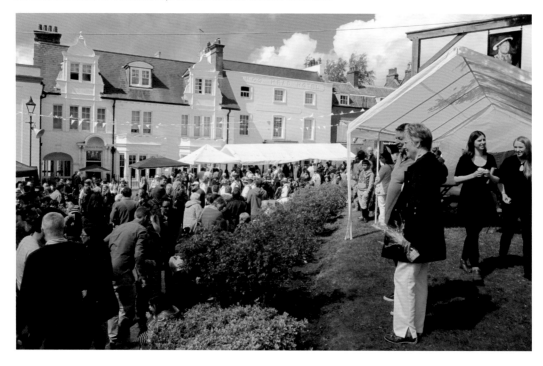

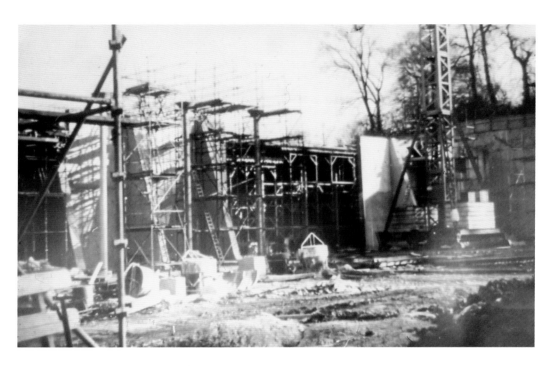

### The Reservoir, Harrow Park

In the early 1970s Harrow Park, off the High Street, became the location of a truly gigantic surface water reservoir. Although its vast chamber holding some 24 million gallons took four years to build, its very existence is now all but forgotten. This is largely due to skilful landscaping which, as the author discovered on a photographic recce, means that little is now visible at street level other than a very large door and a very small flight of steps.

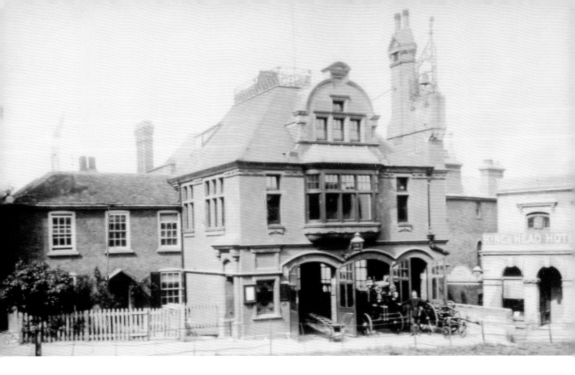

**The Old Fire Station, High Street**

In 1880, the Hill acquired a fire station for its horse-drawn brigade on a site probably chosen for its proximity to the long established King's Head stables. Although the cottage pictured on its other side soon gave way to the Hill's first bank, the fire station itself remained in use until 1963. Its subsequent transformation to an estate agency was achieved with little or no damage to its handsome façade.

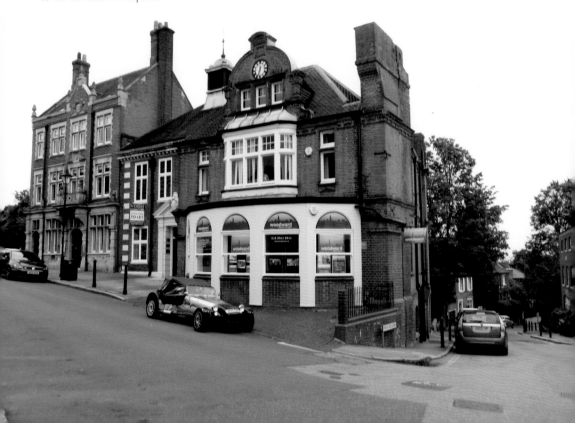

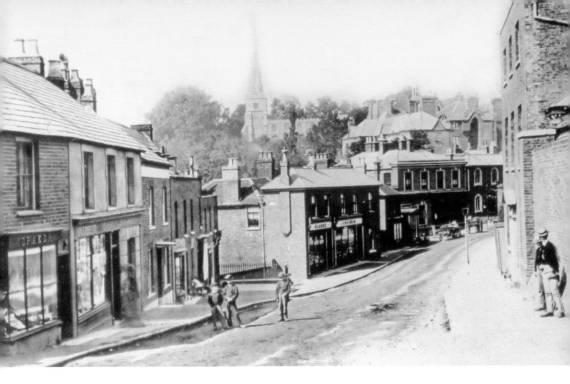

### High Street, pre-1880

Several visual clues suggest that this High Street view is exceptionally old. For a start, the town pump demolished in 1880 is still visible beyond the furthermost shop while the early camera has captured only a 'ghost' image of the moving lady (*left*). Note the straw-hatted scholars warily eyeing the urchins in the manure-strewn road. Such details apart, it is interesting to mention that our companion picture reveals only minimum changes to the street itself.

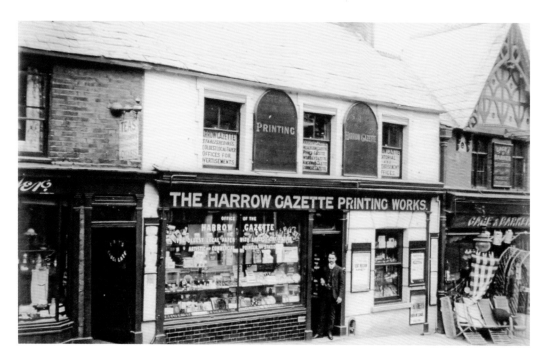

### The Local Paper, *c.* 1905 and *c.* 1935

Founded as long ago as 1855, the *Harrow Gazette* certainly earns a place in our look-back. Like most of the town's services, it began life in the High Street (shown here *c.* 1905) but subsequently moved downhill to College Road next to The Havelock Arms. Here, renamed the *Harrow Observer*, it had a modest front office leading directly into a large multi-storey printing works. Sadly, these pictures have no contemporary counterpart as the *Observer* ceased publication in print form in December, 2014.

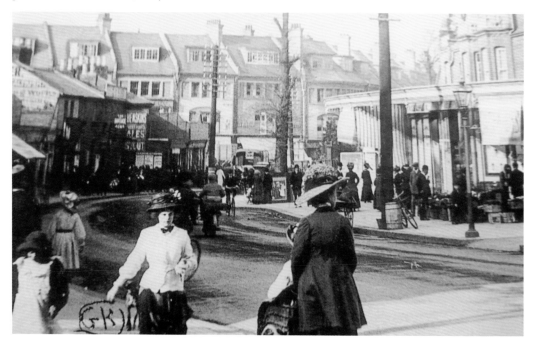

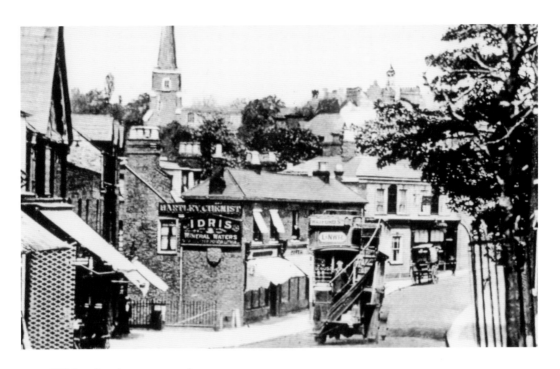

### Hill Bus Services, 1905 and 2015

With only a single horse and cart in sight, the driver of this Watford-based LNWR omnibus was unlikely to have time-keeping problems as he chugged his way along the High Street near the West Street junction *c.* 1905. By contrast, the two bus services that must currently traverse this all-too-narrow road are frequently delayed, even gridlocked. Regrettably, the situation is often aggravated by the reckless and thoughtless parking of other road users.

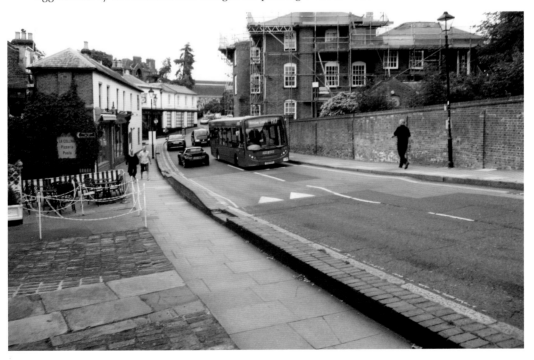

### The Well, High Street

Long after the Hill had become a popular shopping destination, locals were drawing water from the biggest of the town wells, pictured *c.* 1875. Almost certainly medieval in origin, it is known to have been enlarged *c.* 1560 by William Gerrard, then living at the nearby Manor House. When the well was finally closed in 1880, businessman Thomas Hudson replaced it with a drinking fountain. This, in turn, was restored last century by the generosity of the Harrow Hill Trust.

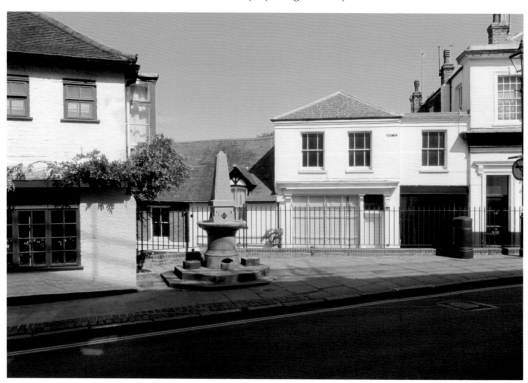

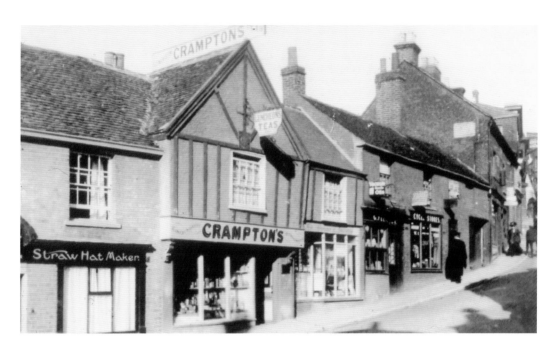

## Old West Street Shops

Cramptons, a favourite tea-house and Rabjohn, the straw hat maker, near the top of West Street, were typical of the 100 traders listed in the Hill's 1850 guide book. After many of them became private residences last century, the building at No. 13 (with pointed gable) was found to be even older. When a run away lorry crashed into its frontage, subsequent repair work revealed a long-hidden original façade now dated to the mid-seventeenth century.

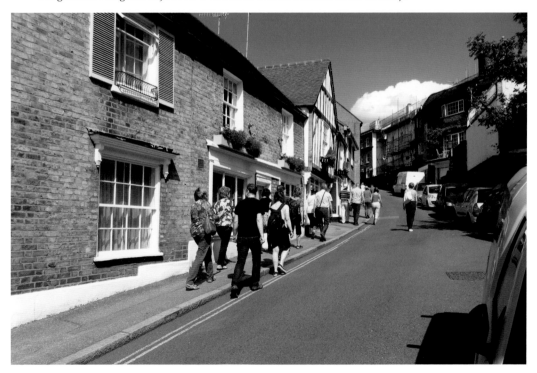

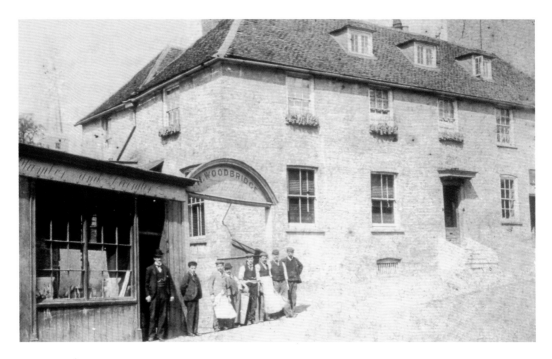

## The Old Poor House, West Street

Hard to believe that this highly agreeable residence, photographed here over a century ago, was built in 1724 as the town's work house, using old timber taken from the recently demolished schoolhouse in St Mary's churchyard. Since the latter is reliably thought to have been the forerunner of today's Harrow School it seems wholly appropriate that, in more recent years, the West Street property has been home to a member of the School's Chaplaincy.

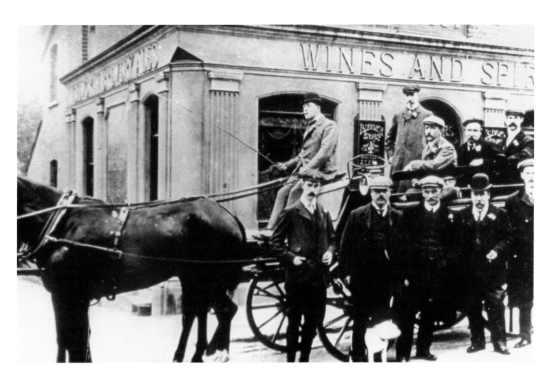

### The Cricketers Inn, West Street

Sited at the junction with Nelson Road, only 100 yards or so from Harrow School's cricket grounds, West Street's only public house was inevitably called The Cricketers. Now – and for many decades – a private residence, it was undergoing an extensive refit when photographed in summer 2015. Coincidentally, the red-painted neighbouring house is now occupied by a building firm specialising in the restoration of comparable Victorian/Edwardian properties.

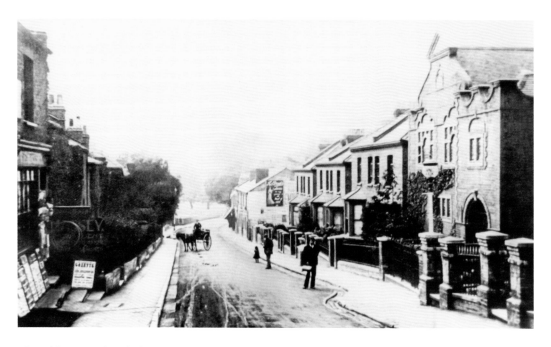

### The Old St Mary's Mission House, West Street

Some two decades before our picture c. 1907, the middle of West Street acquired this imposing red-brick Mission House. Designed by E. S. Prior for those who could not manage the uphill climb to St Mary's, this has long since become a plastic components factory which also occupies an even more fascinating property at its rear. As the adjoining page reveals, this so-called Pye House is actually the second oldest building in Harrow after St Mary's itself.

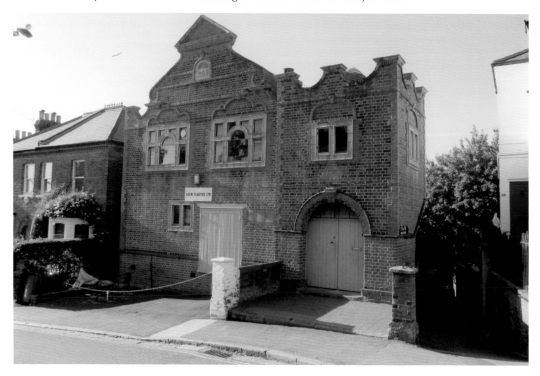

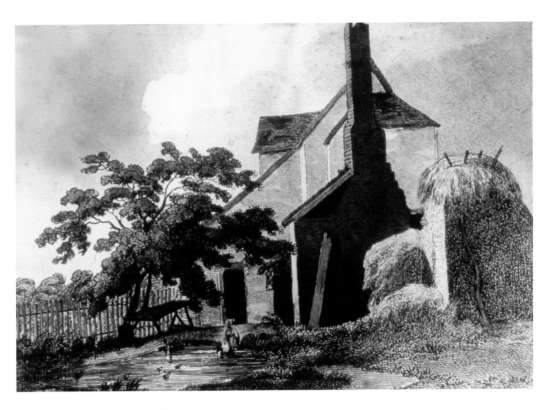

**The Old Pye House, off West Street**

Shown here in a 1795 etching, the Pye Powder House was actually erected *c.* 1350 as a court-house serving the fairs and markets on the nearby Church Fields. The name is thought to be a corruption of the Norman French *pied poudreaux* (dusty feet), indicating the rough ground on which it was built. Today its very existence is largely forgotten, not least because fencing and shrubbery now make it all but invisible from the footpath where our modern picture was taken.

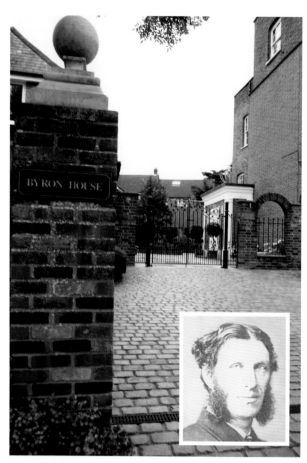

**Byron House, Byron Hill Road**
Why did Pond House, built in the late eighteenth century and famed as the home of poet Matthew Arnold (pictured), change its name to Byron House, a name also given to the present road in 1863? One popular if unlikely theory is that Byron may have once lodged there during the years the property was used as a Small House for Harrow School. That however, would have been decades before the Revd E. Gilliat was photographed there with family and pupils *c.* 1889.

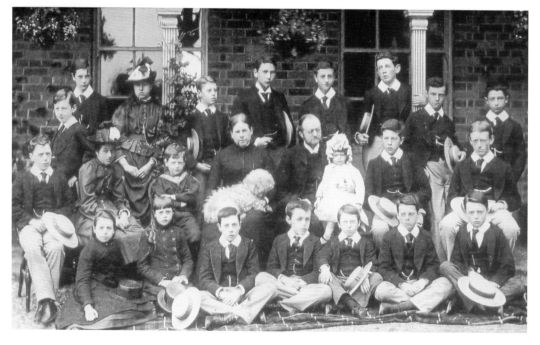

**Byron House, Byron Hill Road**

Possible Byron links apart, it is Matthew Arnold that Byron House rightly celebrates for his triple career as poet, critic and educationalist. Since 2001 the front façade in Clonmel Close has honoured him with a blue plaque which this author was privileged to unveil. The garden side also recalls another eminent Victorian, the architect E. S. Prior. In 1887, he gave the eighteenth-century house a sympathetic new wing graced by an attractive timbered pergola.

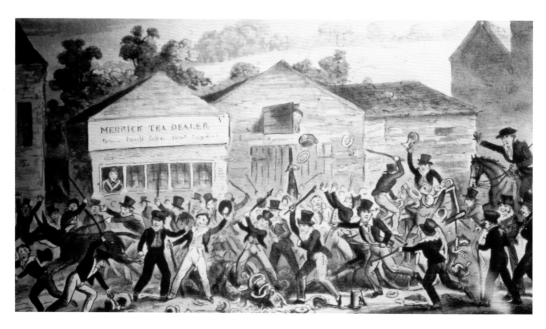

## Crown Street

One of our oldest roads, Crown Street is the setting for this topical George Cruickshank cartoon in which a mob of Harrow School boys are hell-bent on sabotaging a delivery of china to a local tea dealer. Cruikshank uses the old name of 'Hog Lane' for what was once a dank thoroughfare known for its outbreaks of cholera. Today's residential street could hardly be more desirable – especially to estate agents – in part due to a 1970s regeneration.

## Waldron Road

The 1970s regeneration had its greatest impact around the Crown Street/Waldron Road junction where air raid damage followed by years of neglect had seen many properties, including the old North Star, fall into disrepair. Spearheaded by the Harrow Hill Trust and spread over a number of years, the scheme ultimately found builders capable of genuinely sympathetic restoration. Today, the greatest tribute to their work is the virtual impossibility of distinguishing between the very old and the relatively new.

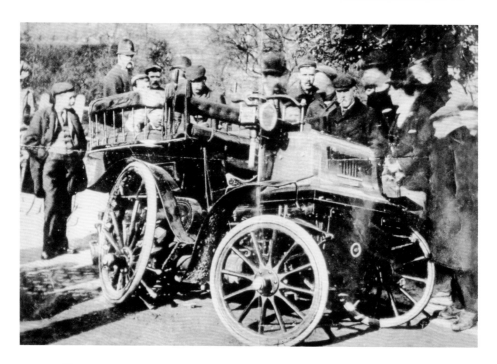

## Grove Hill

Britain's first-ever fatal accident in a petrol-driven car happened on the very steep Grove Hill in 1899 after its driver was obliged to brake so violently that he overturned his open-topped vehicle, killing both himself and one of his passengers. A plaque was later erected some distance from the accident site, serving more as a commemoration than an actual warning. In any event, recent re-routing means motorists can no longer drive down the hill from top to bottom.

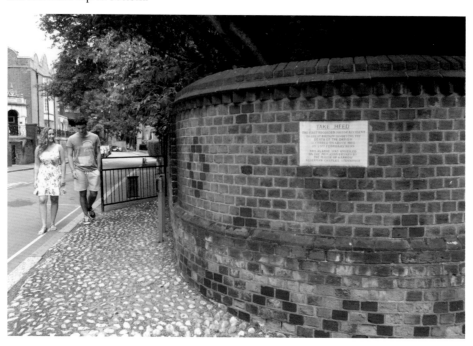

## Manor Lodge, London Road

When this book's author was building his present home in the 1950s, this fantastic property was its immediate neighbour, making little sense of the council's advice 'to build in keeping with the surroundings!' Despite its size, Manor Lodge was actually designed by local architect E. S. Prior in 1883 as a single family residence. Over seventy years later, it was so out of fashion that demolition was permitted and a row of pleasant maisonettes arose in its place.

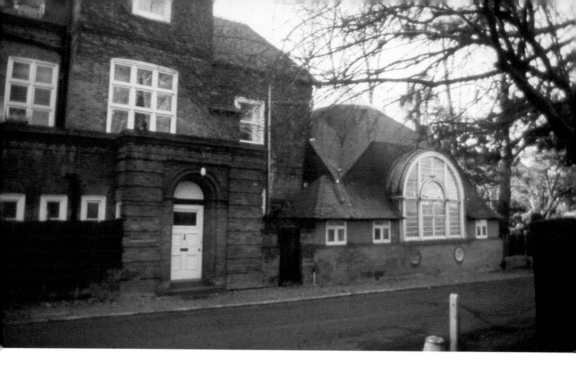

## The Billiards Room, Mount Park Road

Once conservation had become a buzz-word, some surprising planning decisions were perhaps inevitable. For example, developers wishing to replace Bermuda House (previously Corran) with apartments were granted permission only if its billiards room – an 1889 addition by the ubiquitous E. S. Prior – was preserved. The amazing solution was to transform the one, admittedly large, room with a splendid round-headed window and roof-top dome into a small yet complete residence. Its name? What else but The Billiards Room!

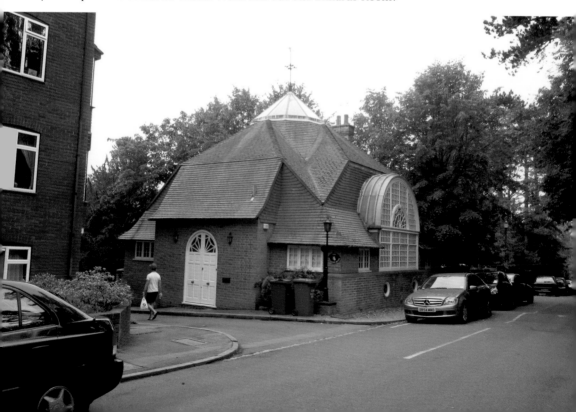

**Peterborough Road, *c.* 1950**

Harrow School names are everywhere! It is 186 years since Head Master George Butler left but he is still remembered locally not only by a Butler Road but also by this main thoroughfare leading off the Hill. It is actually called Peterborough Road but only because Butler later became that city's dean. Much of it is still recognisably Victorian but, on the approach to Central Harrow, the older properties have given way to offices and apartment blocks.

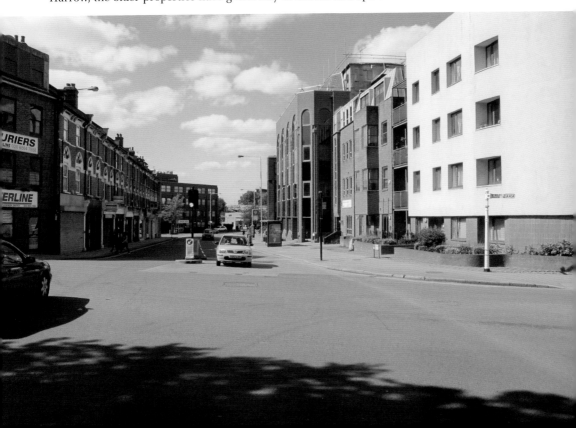

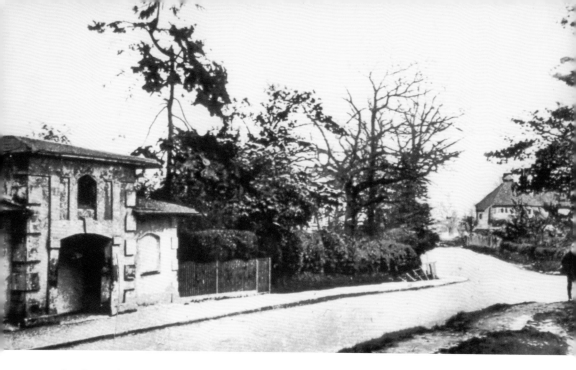

**Lowlands Road, Harrow**

Now one of Harrow's busiest through routes, Lowlands Road take its name from a Georgian villa called Lowlands. In the early nineteenth century, it was the home of a wealthy magistrate Benjamin Rotch who is said to have used this long-vanished lodge as an occasional courtroom. The villa survives but is now totally dwarfed by the many more recent buildings that make up today's Harrow College. These include the former Girls' County School founded in 1913.

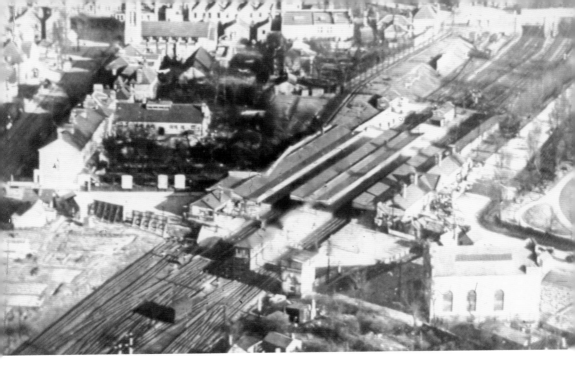

### Lowlands Recreation Ground

When this aerial picture was taken *c*. 1923 above the first Metropolitan Station (*centre*), many other now-lost landmarks were still in existence. They include (*top left*) the tower of the original Harrow Baptist Church and, to its right, the twin cupolas above the Harrow Coliseum. The circular space on the far right is part of Lowlands Recreation Ground. This has not only survived but has recently been given an expensive face-lift and now boasts a small but attractive outdoor theatre.

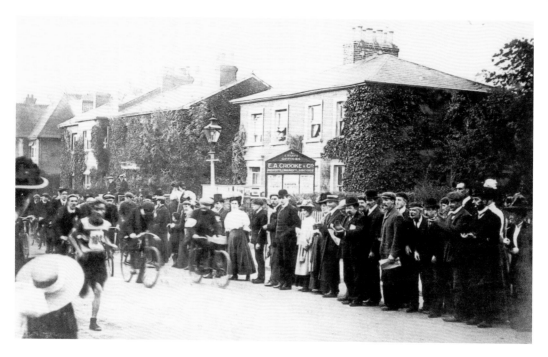

Lowlands Road: *London Evening News* Marathon, 1909

In the decade before the First World War, several newspapers capitalized on the popularity of the Olympic Marathon run through Harrow by staging similar if more modest events in the town. We show the *London Evening News* Marathon of 1909 as pictured by Gifford of Roxeth from a viewpoint in Lowlands Road. Although this site is now occupied by an office block, the other side of the road still retains some of its original houses.

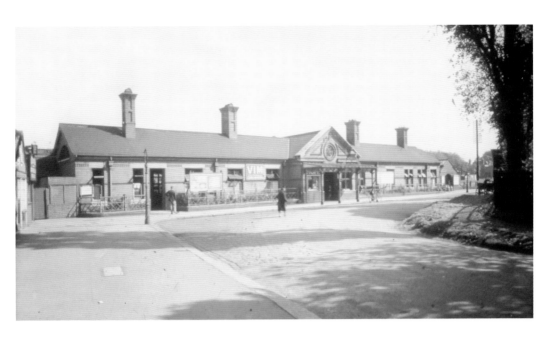

### Harrow on the Hill Station

That the Metropolitan Line station in Harrow is called Harrow on the Hill might seem wholly perverse until one realises that, when first built in 1880, it served a town that was almost entirely centred on Harrow Hill; indeed, its main entrance was actually on the Hill side. Today most passengers exit on the Station Road side which since the 1990s has offered an integrated bus station with links to every part of the Borough.

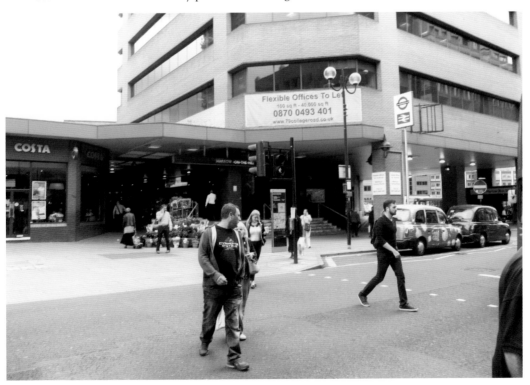

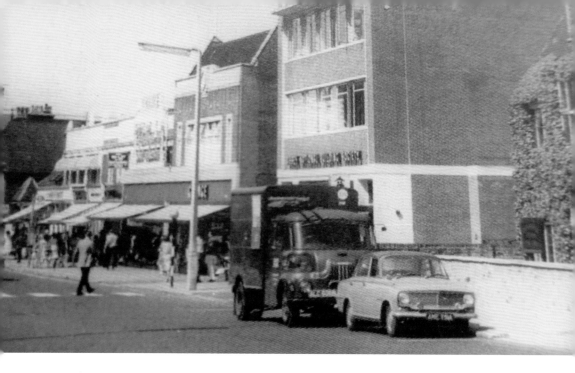

## St Ann's Centre

Nothing has brought greater change to Central Harrow than the advent of its two large shopping centres of which the first was the St Ann's Centre opened in March 1987. Its siting in College Road meant the loss of many of its long established buildings including Heathfield School, whose ivy covering can be glimpsed on the right. Now the whole area is dominated by the mall's vast frontage which, from necessity, incorporates an eleven-storey car park.

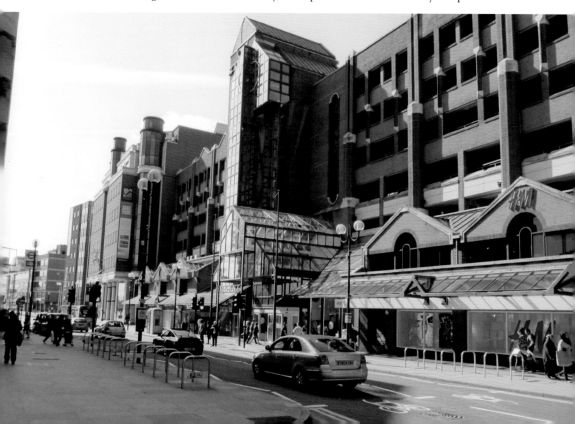

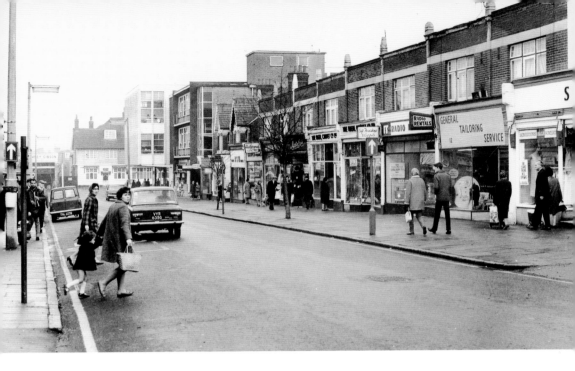

## Clarendon Road

In gaining the St Ann's Centre, Harrow totally lost a pleasant old shopping street named Clarendon Road after a Harrow School bigwig; indeed, of all the buildings visible in our mid-twentieth century picture, the only survivor is The Royal Oak public house at the very far end of the road. Otherwise all that now remains is a bleak walk-through, sandwiched between the blank side walls of an office block called Kings House and the elevated drive-in entrance to St Ann's.

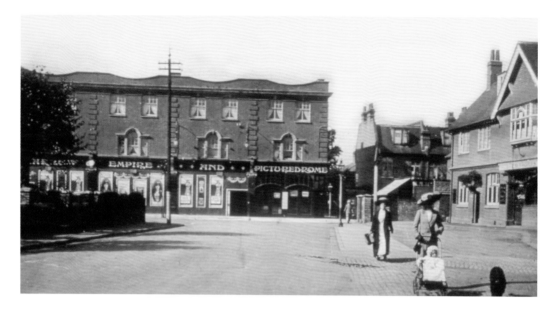

### St George's Centre

It seems highly appropriate that St George's, Harrow's second shopping centre, offers among its many attractions a nine-screen Warner Village cinema because just over 100 years ago the same site housed the district's first-ever picture-palace. Called the Empire and Picturedrome, it survived for a few years only before being converted into Adams, a well-remembered furniture store. The Royal Oak public house, on the right in both pictures, has managed to outlive them both!

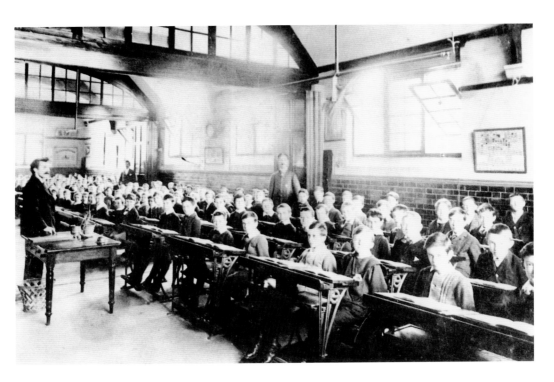

Greenhill School, St Ann's Road

In addition to the well-known buildings demolished in College Road, work on the St Ann's Centre saw many landmarks disappear in nearby St Ann's Road. These included Greenhill School, opened in the 1860s and photographed *c.* 1900 after the addition of a boys' department. Greenhill Laundry was another once familiar feature of an area now dominated by Marks & Spencer, a new Metro Bank and a spectacular entry to the shopping centre itself.

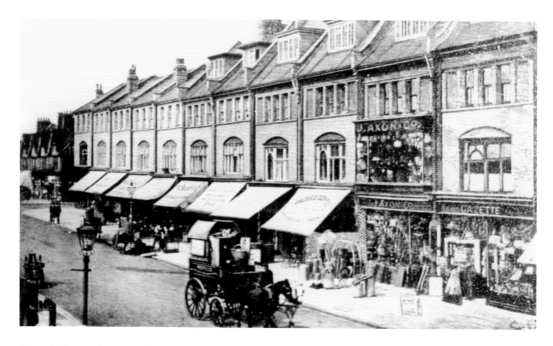

## Greenhill Parade, St Ann's Road

Around the turn of the century, shoppers could look to Greenhill Parade in the certainty of finding bargain goods that not only filled the shop windows – but often the pavements too! Today the road has been pleasantly pedestrianised with ample space for seating. The College Road end also features a charming sculpture of a skipping girl, the sculptor's daughter. Its base records a dedication by Her Majesty the Queen in 1994 to mark Harrow's fiftieth anniversary as a London Borough.

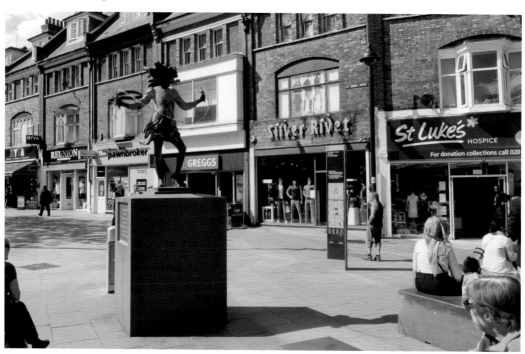

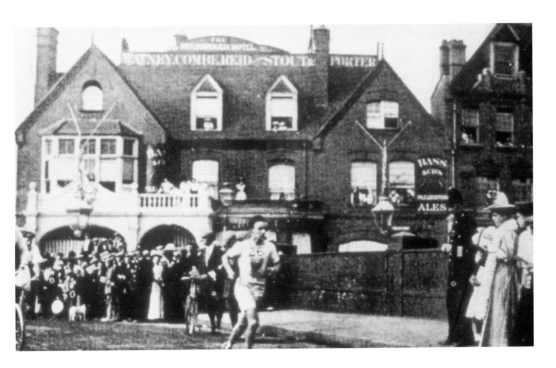

## Roxborough Railway Bridge

Perhaps the Borough's saddest change has been the destruction of the entry to Harrow via Roxborough Bridge. This effectively began with the demolition of the Roxborough Hotel, pictured as the 1908 Olympic Marathon passed over the bridge. The unlovely Aspect Gate rose in its place followed by a vast apartment block which, hit by the recession, remained an ugly skeleton for years. As shown, this is now virtually complete, prompting many to ask if the wait were worthwhile.

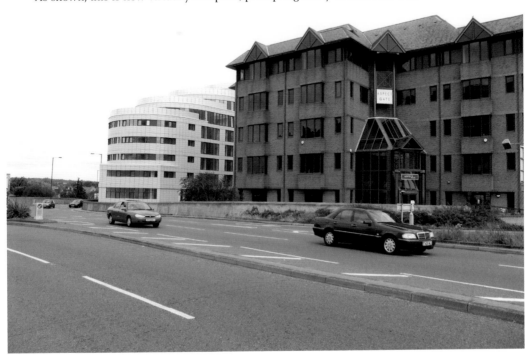

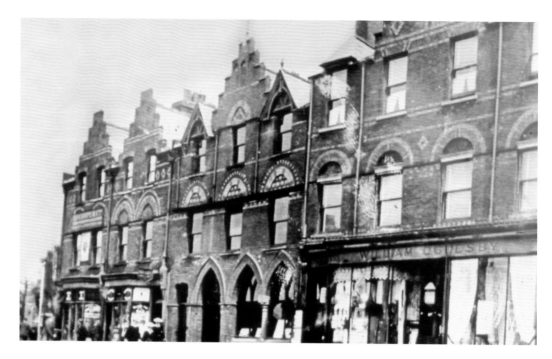

## Early Post Offices

Harrow's Postal Service inevitably began on the Hill. First from the Crown and Anchor inn and, later, from its own premises (with arched doorway) facing the green. Subsequently, the need for expansion forced a move downhill to this handsome building in College Road. Conveniently situated just yards from the Met. Station, it is still fondly remembered by older residents, especially in the light of the less agreeable happenings of recent years.

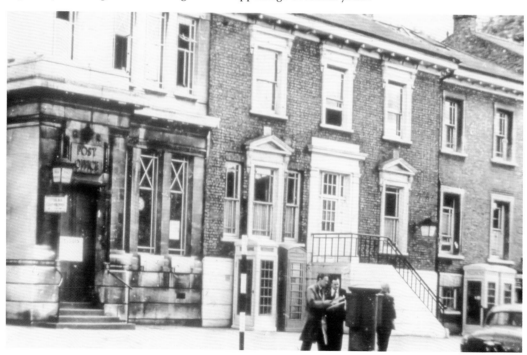

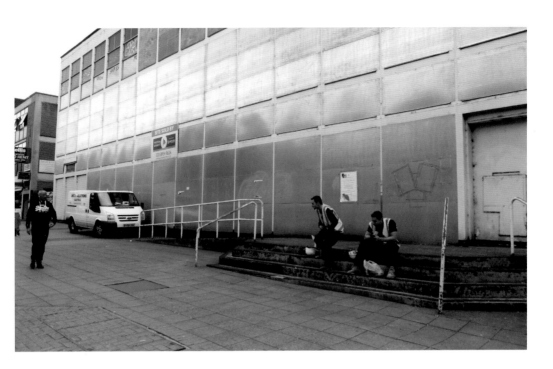

**Old and New Post Offices, 2015**
The 1960s post office was never a beautiful building but no-one could have predicted that it would become the deserted shell of our contemporary picture. But then who could have foreseen that the proposed large scale development of the station side of College Road (which forced the post office to leave) would still be at the planning stage in 2015? Meanwhile, a new post office has opened to the public – but on the other, less threatened, side of the road!

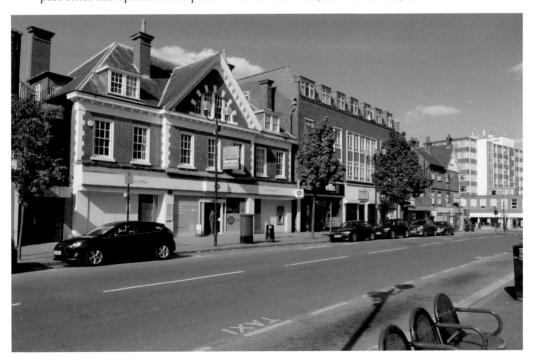

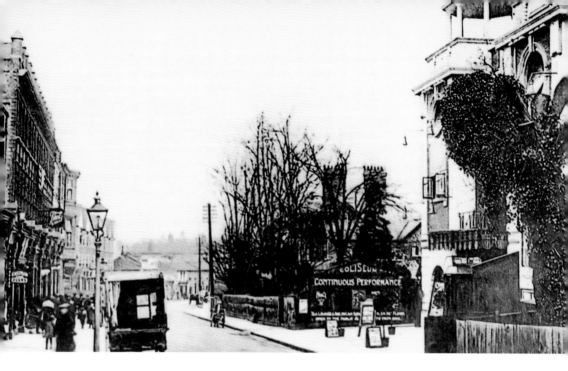

**Harrow Coliseum, Station Road**

For nearly forty years, the first cheering sight for people coming off the Hill was the Harrow Coliseum. Opened in 1920 as a very grand picture-house, it then became a legitimate theatre where many of us saw our first opera, ballet and classic plays. Despite the fact that in 1958 Harrow had no other proper theatre – a situation that still prevails – it was demolished and a supermarket (now Iceland) was built in its place.

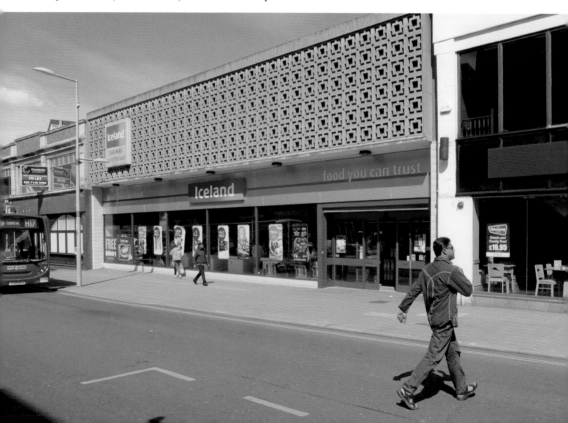

### Early Shops, Station Road

Commercial development *c.* 1900 of this once residential street was in part due to Thomas Lilley and William Skinner, later famous for their nation-wide shoe shops. One of their very first was a so-called 'boot wardrobe' in Station Road whose success prompted houses on the opposite side of the road to become shops themselves – simply by building over the front gardens! Shoppers who look upwards today can still see many of the original upper floors and rooftops.

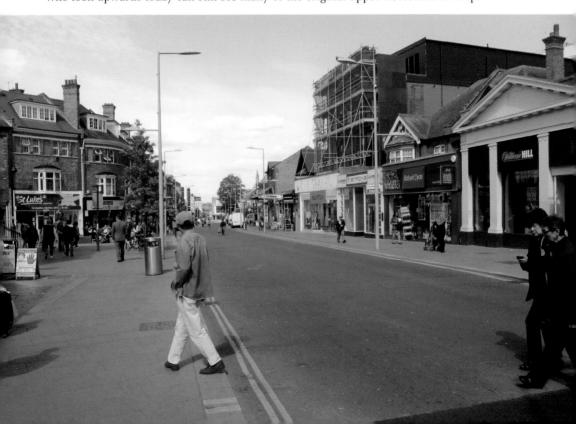

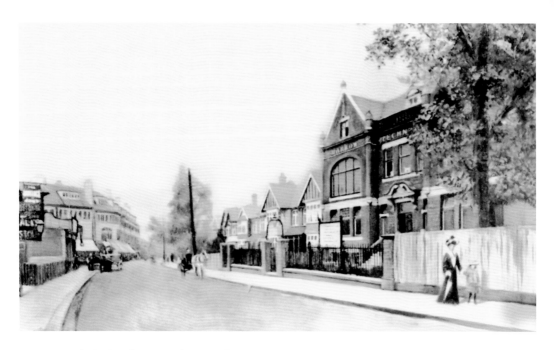

### Harrow Technical College, Station Road

Around 1880 Marion Hewlett virtually invented technical education in Harrow by starting classes in her Hill home for poorly educated young people working as domestic servants. With support from one of Queen Victoria's daughters, the project steadily grew until 1902 when this impressive red-brick building opened as Harrow Technical College. Although the rare lower picture, dating from the 1920s, shows a home-craft class, the school's syllabus already embraced a surprising variety of subjects.

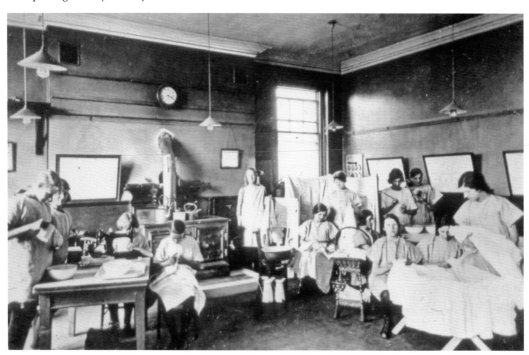

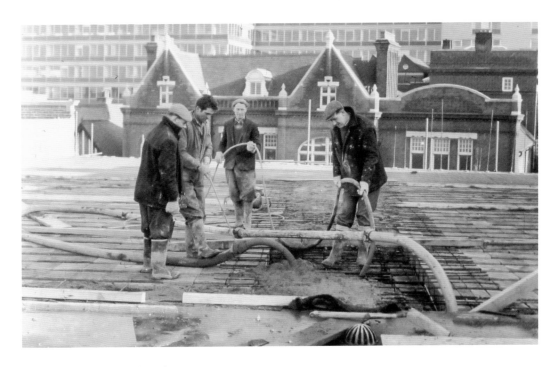

## From Tech to University

The original Tech was still in place in 1967 when the town's skyline was beginning to change with the construction of its first tower blocks. Most of its students however, had already moved to a large green-field site at Northwick Park where, later still, they merged with the more famous Regent Street Polytechnic. Amazingly, Marion Hewlett's little venture has become today's University of Westminster, offering facilities on a scale to which a single photograph can only hint.

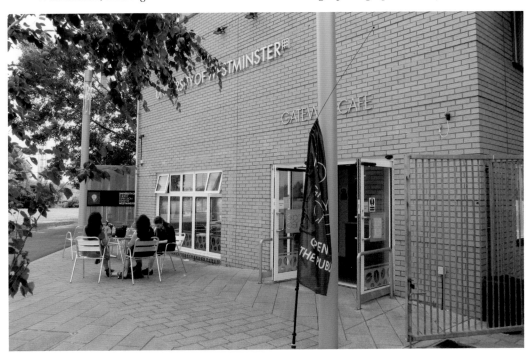

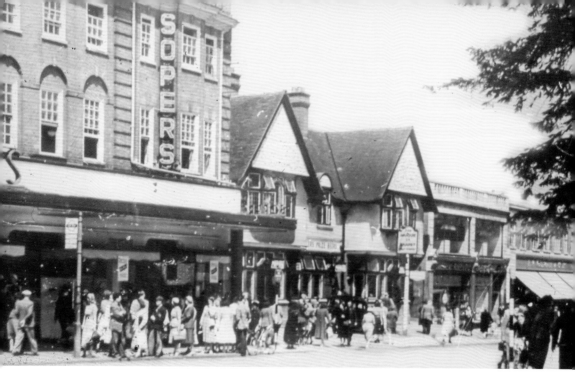

## Sopers, Station Road

From its opening in 1914 Sopers was always the most important of the local shops. Although its owner, Mr W. T. Soper, died in the great post-war influenza epidemic, his store continued to expand, ultimately swallowing up the adjoining Marquis of Granby public house (right in our 1950s shot). Such was the name's value, the store continued to trade as Sopers for several decades following its acquisition in the 1920s by present owners, Debenhams.

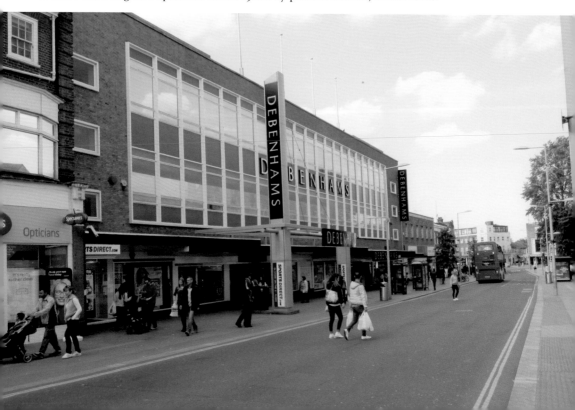

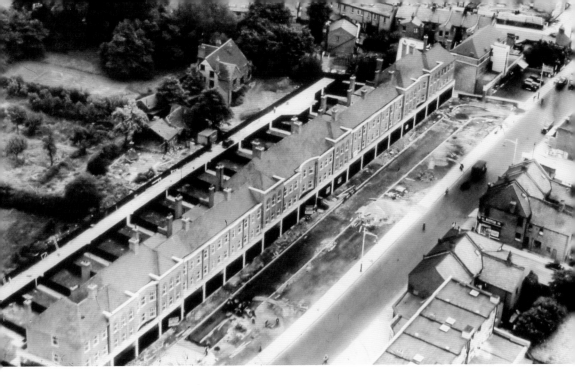

**Manor Parade, Station Road**

When this aerial picture of Station Road was taken in 1937, the shops in the new row known as Manor Parade were still being fitted. Interestingly for us, the camera also captures several long-vanished properties including The Crofts, for many years home to St Margaret's Girls School plus, top right, building work on the soon-to-be-opened Granada Cinema. Having been listed for its art deco interior, the cinema still stands although it is now used as a Gold's Gym.

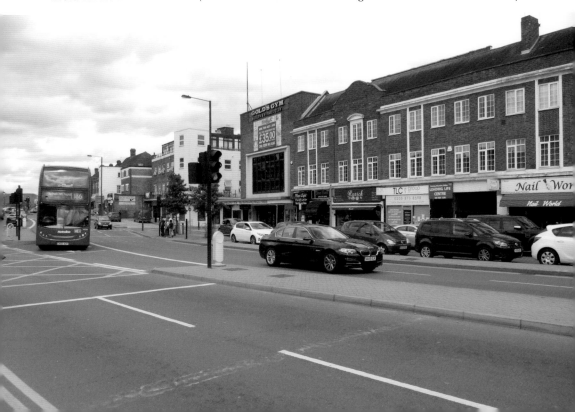

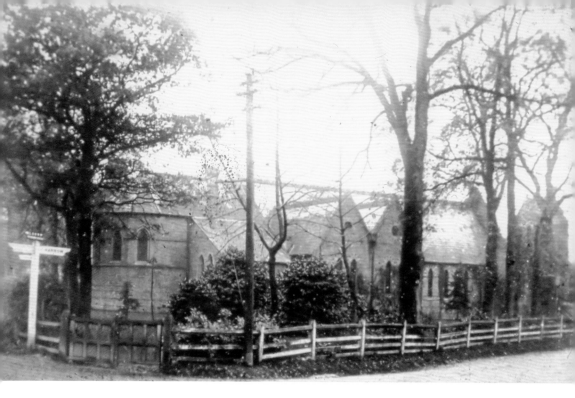

### St John's Greenhill

Pictured shortly after its opening in 1866 the very first St John's, then within the parish of St Mary's, was very different from today's Edwardian edifice, even to the extent of having a separate bell tower (glimpsed on the right). Thirty years later, when St John's had become a parish in its own right, a new building programme was launched. This resulted not only in the present-day church but also a splendid parish hall named for Queen Victoria.

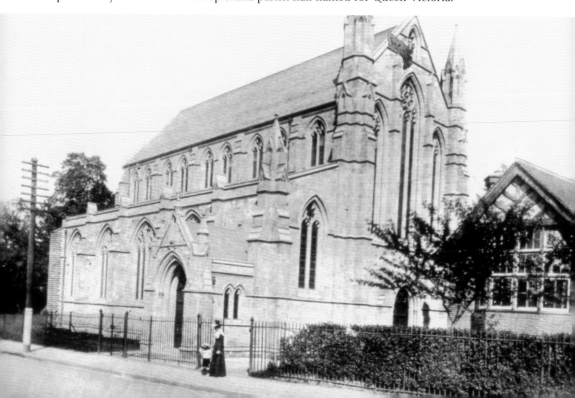

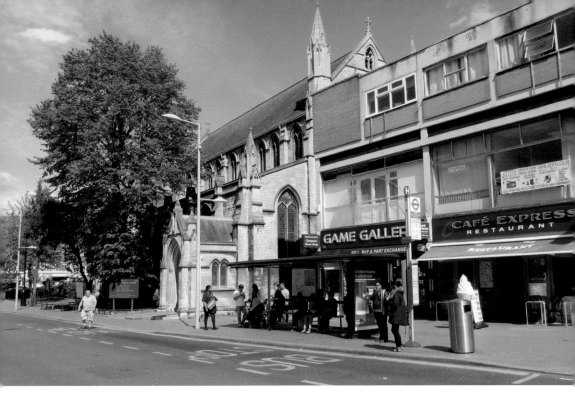

**St John's Church and Hall, 2015**

In more recent times, the visual impact of St John's has been greatly diminished by the construction of neighbouring shops which now hide the whole West side of the church. As for the Victoria Hall, once home to one of the British Restaurants in which a war-time populace gratefully eked out their rations, this has been rebuilt as a set of modern assembly rooms. It has, however, a different setting – around the corner in Sheepcote Road.

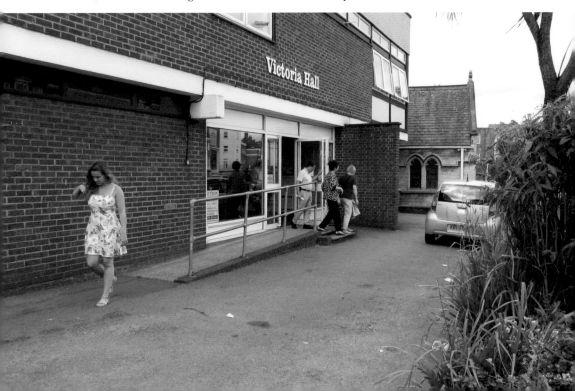

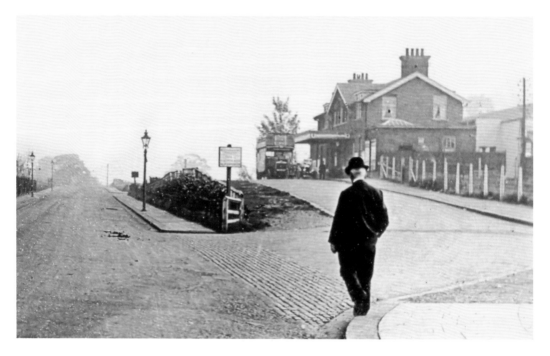

**South Harrow Station, *c.* 1903**

South Harrow is largely the invention of the railway. When its first station was opened in 1903, the railway authority of the day ignored the area's traditional name of Roxeth (extant since AD 845) in favour of one that was easier to spell and pronounce! Built some distance from the main road, this first station still stands in today's car park providing a remarkable contrast with its successor designed in 1932 in the London Transport style of the day.

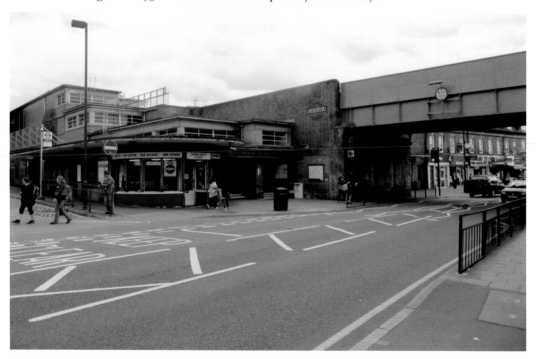

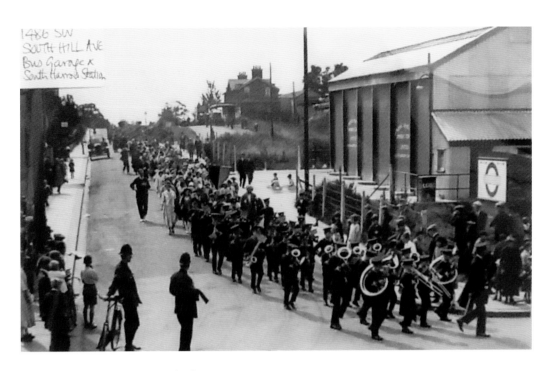

1486 SW
SOUTH HILL AVE
Bus Garage x
South Harrow Station

### South Harrow Bus Terminal

While the new railway was speeding locals to the capital's shops, theatres and museums, many Londoners were making the reverse journey to enjoy Roxeth's semi-rural delights. On one occasion in the mid-1920s scores of London schoolchildren were even greeted with a musical welcome from the Roxeth Boys Brigade Band! South Harrow then had its own bus garage but this has long since been replaced by a turning point and passenger shelter. Photograph courtesy of Harrow Local History Collection.

**Roxeth Gas Works, Northolt Road**

Having successfully sought 'the patronage of the gentry and inhabitants to assist his speculation', local entrepreneur Thomas Chapman brought gas to Harrow as early as 1855. The choice of Northolt Road for the works was initially well received but, as the demand for gas grew, so did the size of the gas holders. Finally, in the early 1930s, in the face of great opposition a holder was erected 240 feet high and 162 feet in diameter.

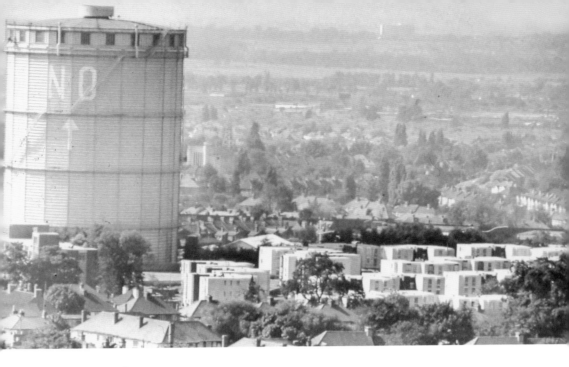

### From Gasworks to Superstore

The much reviled holder was still in place in the mid-1980s even though its useful life had ended. By then, a gigantic 'NO' had been painted on its side as a warning to aircraft after a large commercial plane had landed at nearby Northolt in mistake for Heathrow, which is close to Southall's very similar holder! The holder was finally dismantled in 1986 and the site decontaminated to permit the building of a Waitrose Supermarket.

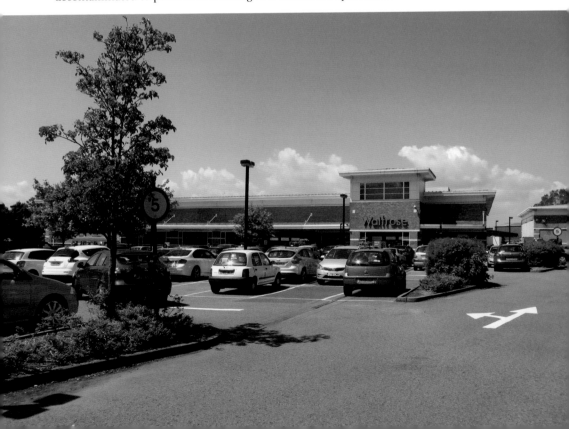

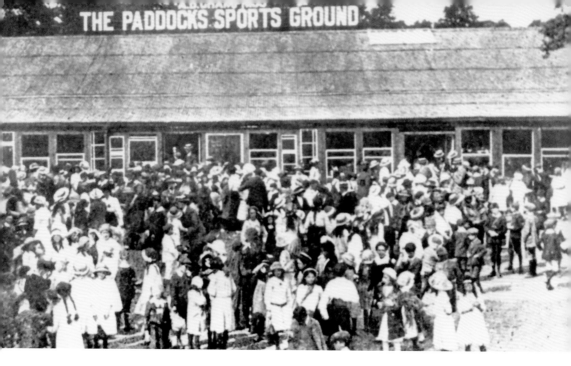

## The Paddocks, Northolt Road

One of several farms towards the Northolt village end of Northolt Road, Grove Farm is best remembered for the pre-First World War years when its owner turned most of his land into a sports and amusement park. Called The Paddocks, its many attractions included a miniature railway, donkey rides and a restaurant catering for up to 3000 visitors. Aptly enough, after its closure in 1926, much of the land became the local recreation ground called Alexandra Park.

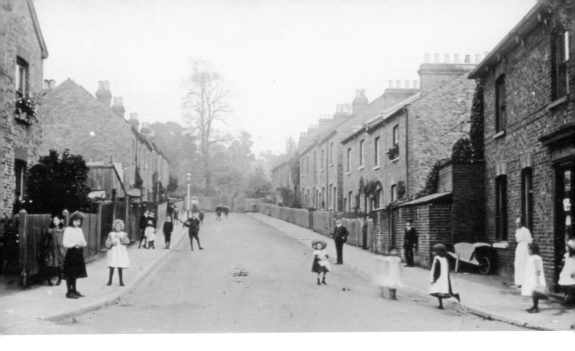

## Grange Road, off Northolt Road

Few streets were more quintessentially Edwardian than Grange Road, whose neighbourliness was well captured *c.* 1907 by Gifford of Roxeth who lived in nearby Alma Road. This whole enclave off Northolt Road remained more or less intact into the early 1970s when it was subject to an extensive redevelopment which removed entire streets (Alma Road among them). Grange Road is now home to an eclectic mix of local authority housing and centres concerned with health and welfare.

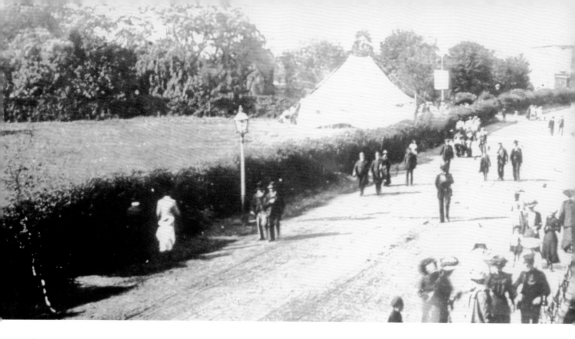

### Grange Farm, Northolt Road

Long after the gasworks were established, much of Northolt Road remained farm-land. Our picture *c.* 1905 shows Grange Farm at a time when a tent-based Baptist Mission was attracting a well-dressed crowd to one of its fields. By contrast, today's visitors are likely to be heading for the newish Eurotraveller Premier Hotel or, perhaps less happily, the adjoining Roxeth Police Station! The latter was a last-century replacement for the long-established West Street station.

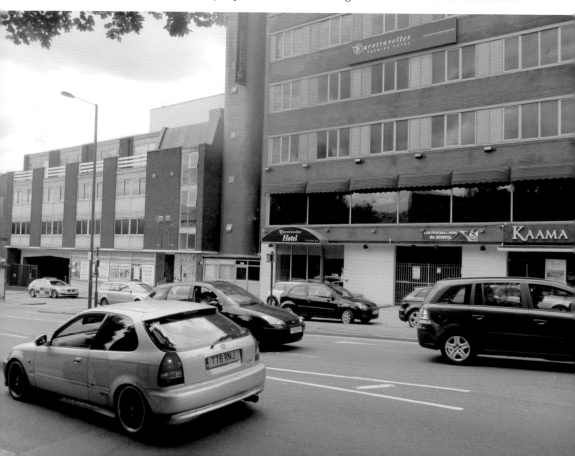

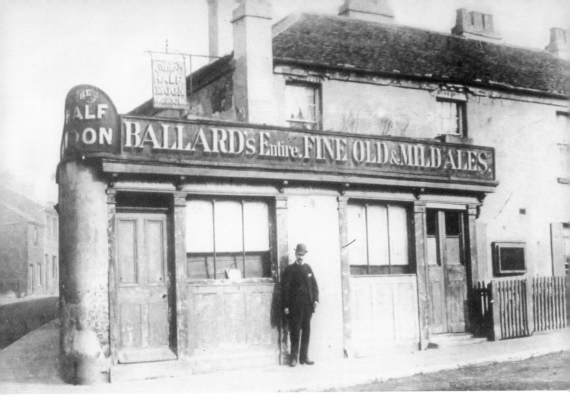

### The Half Moon, Roxeth Corner

For a really old pub one need look no further than Roxeth Corner where there has been a Half Moon since 1862. The somewhat unusual name comes from its proximity to the long vanished St Edmund's Pond, which was itself shaped like a crescent. This original pub, which appears to be a conversion from two cottages, lasted until 1893. It was then replaced by the present premises which are themselves over 120 years old!

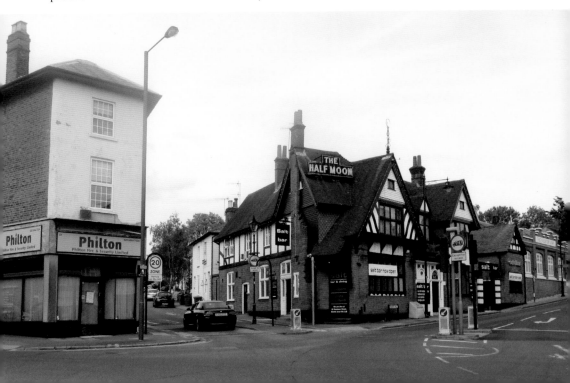

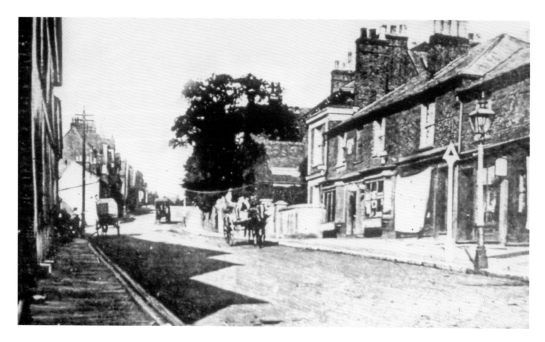

## Middle Road

Middle Road has long brought rewards to those willing to tackle its considerable gradient. Around 1905 there were ample shops including, in one row, a sub-post office, a butcher's and a popular barber's. Today, apart from The White House which is now housed in a twentieth-century rebuild, its pleasures are more architectural. Among the interesting period houses is this unusual terrace by E. S. Prior beyond which can be seen the many and diverse buildings of The John Lyon School.

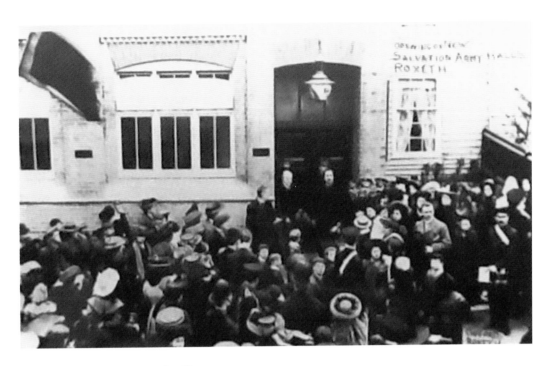

## Salvation Army, Roxeth Hill

In 1886 Roxeth was very much the Hill's poor relation, making it exactly the kind of community to attract the Salvation Army. Their beginnings in an upper room on Roxeth Hill could hardly have been more modest nevertheless their consistent growth over some two decades enabled them to build this fine red-brick citadel, pictured during its 1907 opening. The Army happily continues its good work at the same address, although in greatly modernised premises. Photograph courtesy of Harrow Local History Collection.

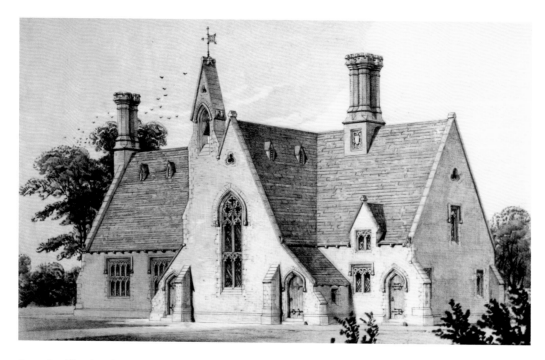

## Roxeth Hill School

Only Harrow School has a longer local history than Roxeth Hill School, founded in 1812 by the Revd John Cunningham, St Mary's Vicar for fifty years. Much later, in 1851, on the death of the schoolboy son of the Earl of Shaftesbury, he persuaded Harrow School to use donations given in the boy's memory to fund the school-house (pictured) instead of a more conventional memorial. Amazingly, this building is still in use at the heart of today's flourishing school.

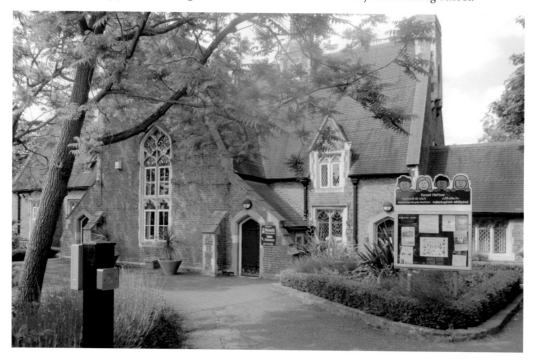

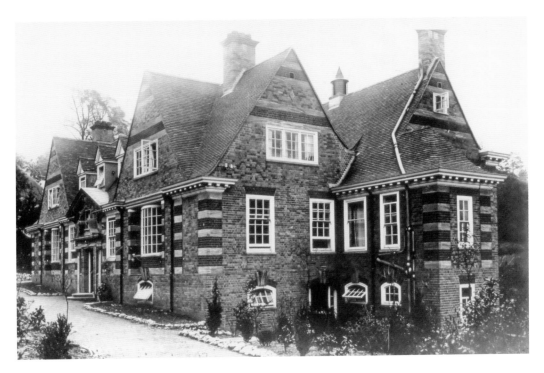

## The Old Cottage Hospital, Roxeth Hill

In tribute to this much-loved Cottage Hospital, Roxeth Hill was long known by locals as 'Hospital Hill'. Designed by Arnold Mitchell in 1906, it served Harrow proudly until the early 1970s when its services were largely transferred to the new Northwick Park Hospital. Since the closure left a huge gap in a sensitive area, it required a public enquiry before a Barratt Homes estate arose with, at its heart, the first hospital building cleverly transformed into luxury apartments.

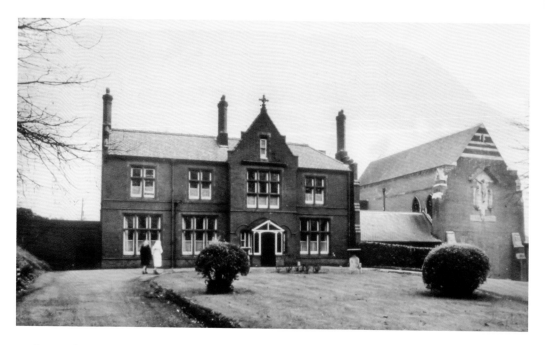

## Sudbury Hill

This ancient link between Wembley and Harrow remained relatively undeveloped up to the Second World War and beyond. Then the closure of the vast Convent of the Visitation saw increasing demands to build. Despite local opposition and the inevitable public enquiries, the results were mixed. They included the over emphatic bulk of the Chasewood Park apartments (illustrated) and, lower down the hill, a private hospital, The Clementine Churchill, named after Winston's wife.

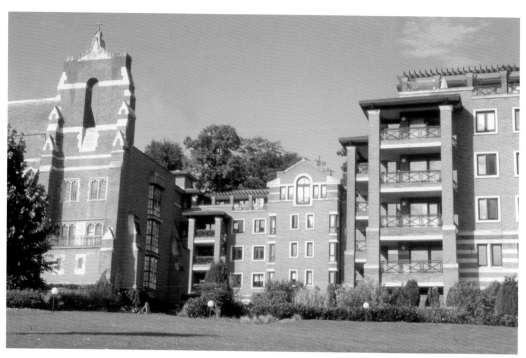

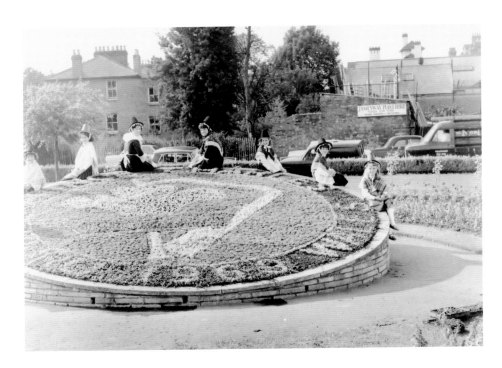

## Harrow Civic Centre

In 1969, Poets Corner, a well-known Wealdstone landmark at the confluence of several roads named after famous poets, proved a popular choice for the creation of a floral clock marking the investiture of Prince Charles as Prince of Wales. Within a few years however, the whole district had been levelled to make way for Harrow's first Civic Centre. The product of a national design competition, its somewhat plain façade has since been enlivened by ambitious planting.

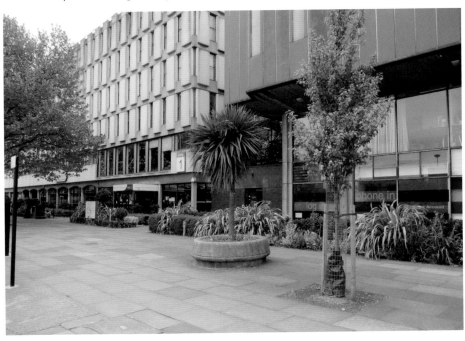

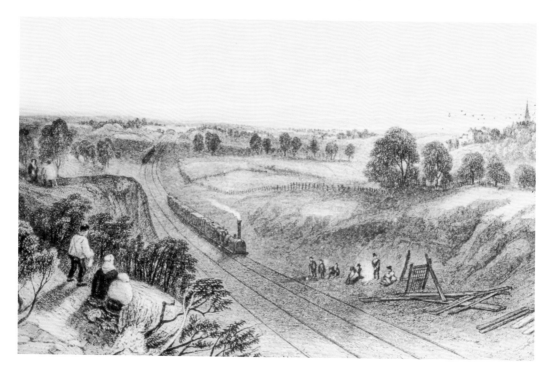

### Harrow's first railway station

This artist's impression c. 1839 of a train puffing its way through a landscape virtually empty apart from St Mary's Church is perhaps the only surviving reminder of Harrow's first railway station which opened in Wealdstone as long ago as 1837. As our lower picture reveals, by 1912 the station had already gained a massive covered footbridge linking its many platforms. Sadly, this was to figure dramatically in the unforgettable disaster recorded on the facing page.

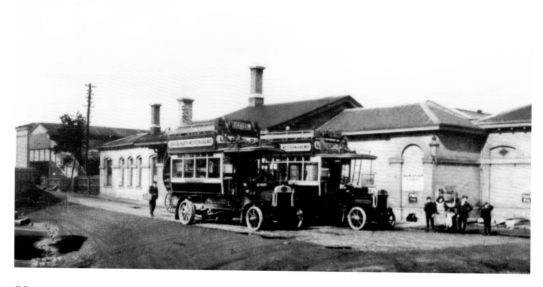

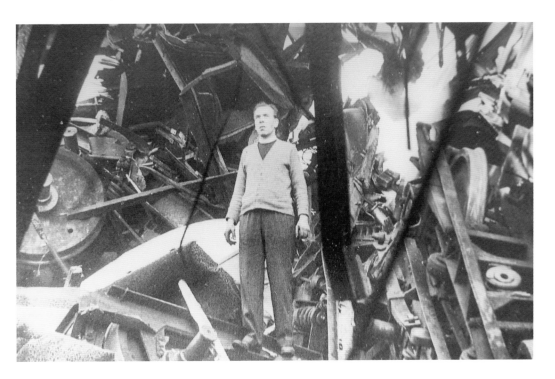

## Wealdstone Rail Disaster

In 1952 a stationary commuter train was hit by a Scottish Express, creating massive wreckage that was immediately struck by a second express, forcing much of it upwards through the thronged passenger bridge. The final death toll was a staggering 112 despite the heroic work of professional services and volunteers like the then Vicar of Greenhill. Today their efforts are remembered with gratitude by means of a massive mural. Painted by local schoolchildren, it depicts colourful scenes from Wealdstone's past.

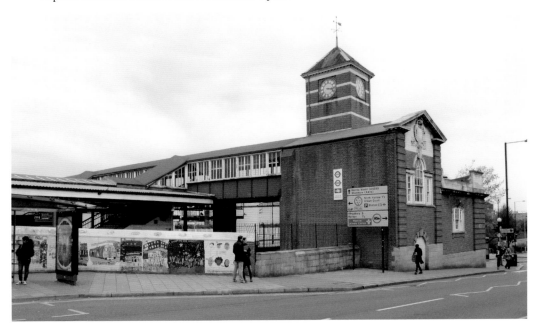

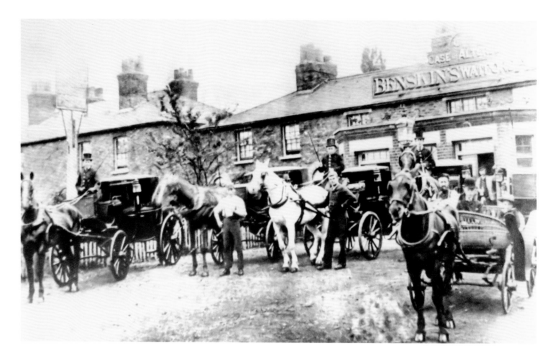

### The Case Is Altered, Wealdstone High Street

With most of its traffic now re-routed to a parallel bypass, the once prosperous High Street has lost not only countless shops but also pubs such as The Case Is Altered, shown here *c.* 1900. After being boarded up for years, this site has recently become home to a Poundland store with apartments on the upper floor. However, its neighbour, the once handsome Magistrates Court of 1908, remains sadly deserted.

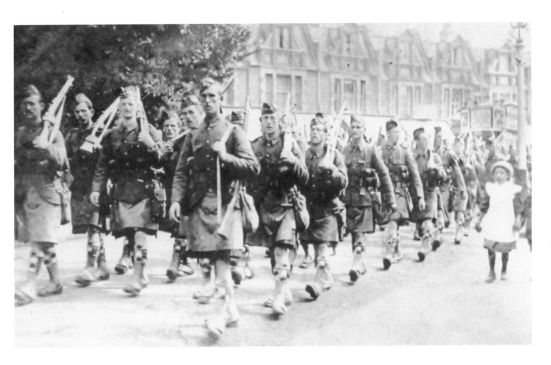

### Trinity Parade, Wealdstone High Street

One of Wealdstone's oldest shopping parades now provides the background to this evocative First World War photograph of men of the Seaforth Highlanders marching to a nearby transit camp – and likely death in the trenches. What makes the picture even more poignant is that they are passing virtually the exact spot where Wealdstone built its war memorial in 1923. It was dedicated by Oswald Mosley who, before his notorious Fascist career, was the local MP.

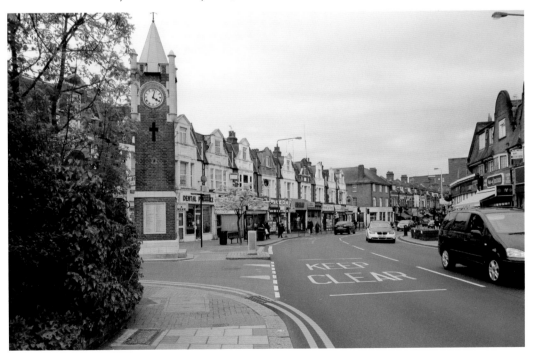

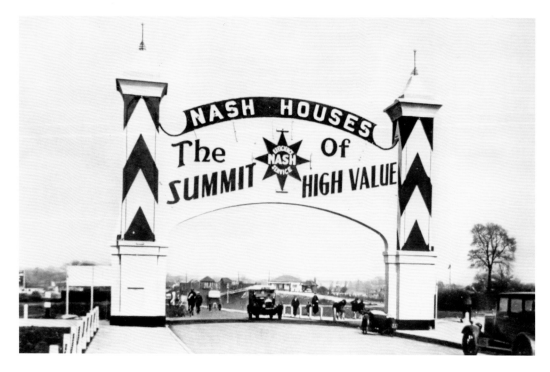

### Alexandra Avenue, Rayners Lane

Probably no one did more to transform districts like Rayners Lane and Kenton than T. F. Nash, a South Harrow-based builder who, at his peak, employed over a thousand workers in constructing what were virtually mini-townships. His publicity was on a similar scale, as shown by this triumphal arch erected in 1934 in a peaceful Alexandra Avenue. Prescient as Nash undoubtedly was, even he might be surprised by the typical Outer London suburban scene the same viewpoint now presents.

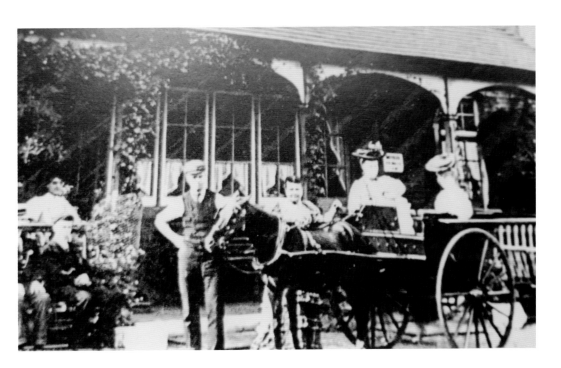

### The Old Rest Hotel, Kenton

Far from new when photographed *c.* 1908, the Rest Hotel has witnessed vast changes, not least the building of neighbouring estates by developers such as T. F. Nash and Frederick and Charles Costain. Originally a popular meeting place for cyclists and ramblers, the hotel itself has survived several name changes and a rebuilding in 1933. Today, as the Travellers Rest, it is part of the well-known Beefeater steak-house chain.

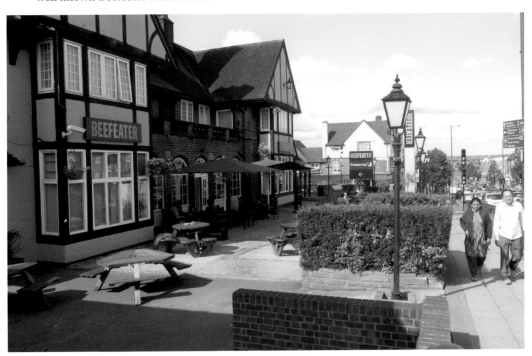

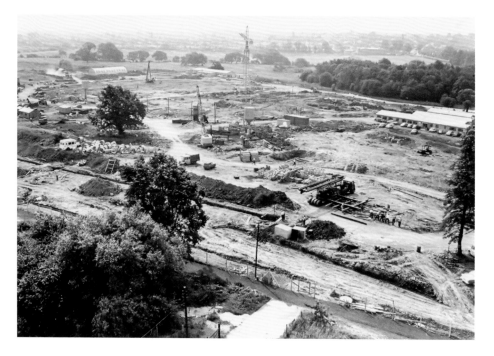

## Northwick Park Hospital I

Once part of the estate of Lord Northwick and subsequently home to Northwick Park Golf Club, these green fields proved an ideal site for the long-awaited replacement to the overstretched Cottage Hospital. A major undertaking by any standards, it took some four years before the first patients were admitted in September 1970. One month later, the local press photographed the hundreds queueing in readiness for the opening ceremony by a very special guest.

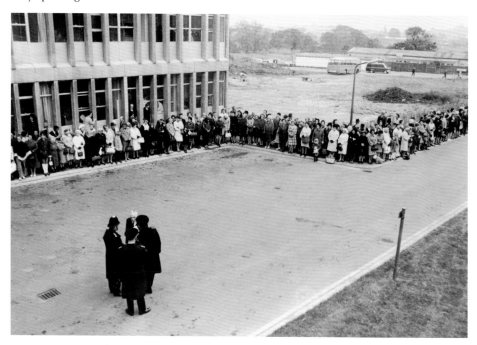

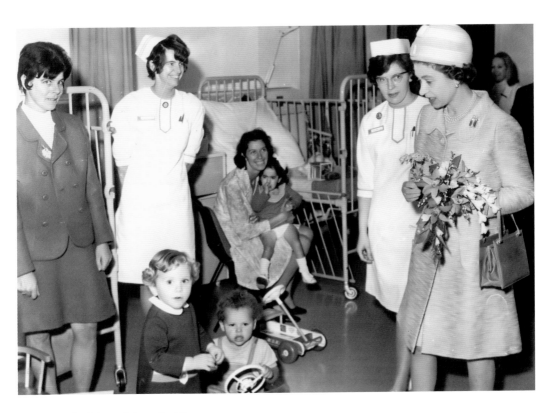

**Northwick Park Hospital II**

On one of her relatively rare visits to Harrow Town as distinct from Harrow School, Elizabeth II not only performed the opening ceremony but also toured many departments including the children's ward. Forty-five years later, Northwick Park is among the county's biggest and busiest hospitals recently adding four new theatres and a £21 million A&E department. Such has been the parallel growth of Harrow however, a complete rebuild may yet prove essential.

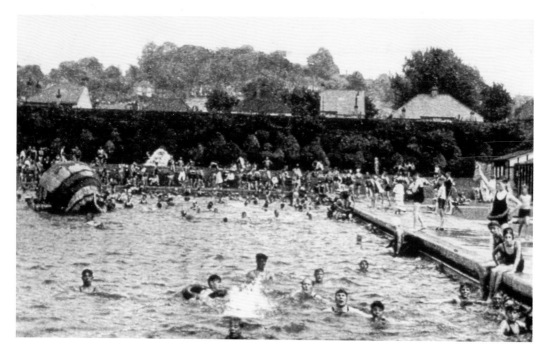

**Pool Road, Harrow**

For much of the last century, Harrow could claim two outdoor pools in unusually attractive settings: Harrow School's Ducker and, in the midst of a newly-built housing estate, the council-run Charles Crescent Baths with superb views of hill-top St Mary's Church. Though long since built over, the latter pool is not entirely forgotten for its site is now called Pool Road from which glimpses of St Mary's spire can still be seen.